SOUTHEND IN 50 BUILDINGS

IAN YEARSLEY

AMBERLEY

First published 2016

Amberley Publishing, The Hill, Stroud
Gloucestershire GL5 4EP

www.amberley-books.com

British Library Cataloguing in Publication Data.
A catalogue record for this book is available from the British Library.

ISBN 978 1 4456 5188 0 (print)
ISBN 978 1 4456 5189 7 (ebook)

Typesetting and Origination by Amberley Publishing.
Printed in Great Britain.

Contents

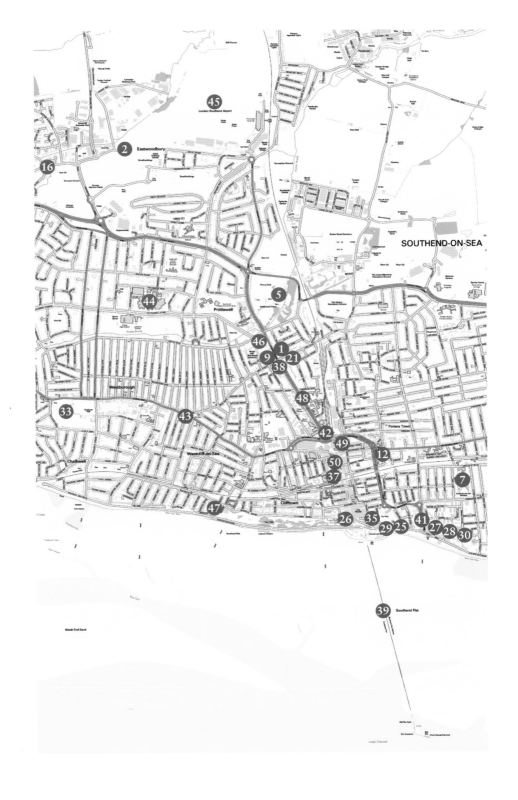

SOUTHEND-ON-SEA

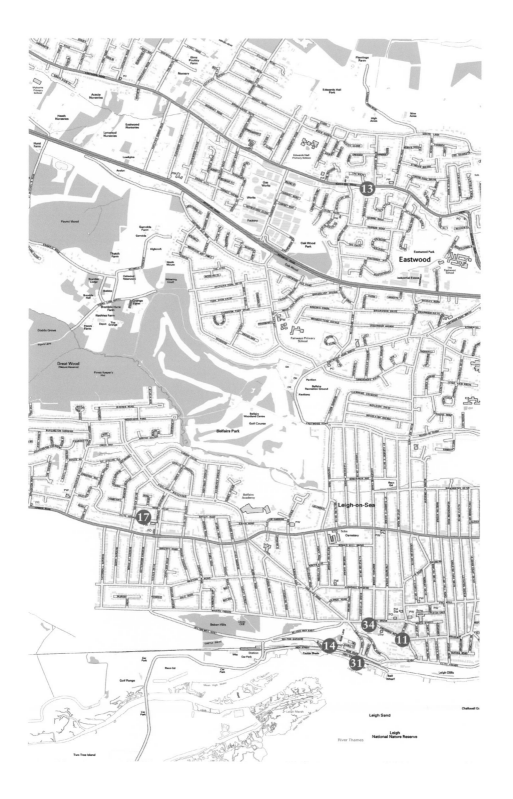

Introduction

This book tells the story of Southend through fifty of its buildings. The built environment is all around us. It shapes our lives, physically and figuratively. We carry around in our heads a mental picture of our town which helps us to recognise its landmarks and navigate its streets. It is tempting to think of that townscape as static, but in reality it is ever-changing.

Southend is a comparatively modern town. Although the word 'Sowthende' crops up as early as 1481, the town's true origins date only to the eighteenth century, when it was established as an oyster fishing hamlet at the 'South End' of Prittlewell parish. That hamlet quickly became a fashionable sea-bathing resort, and by the 1790s it was being actively transformed into a town.

The arrival of the railway in 1856 really set change in motion, kick-starting rapid growth. The town was still then governed administratively from Prittlewell, but ten years later the Southend Local Board (forerunner of the modern Council) was set up to give Southenders control over their own affairs. In 1877 the comparative significance of Southend over Prittlewell was confirmed when the Local Board was given control of the whole of Prittlewell parish. 'South End', originally a geographical description, had become Southend, a town and administrative area.

In 1892 the Local Board was replaced by a town council, which had greater powers. Five years later that council took over the administration of neighbouring Southchurch parish. In 1913 it absorbed Leigh Urban District Council, and with it the administration of the old Leigh parish and the southern bit of Eastwood. In 1914 the town council was promoted to county borough status and in 1933 the county borough took over the administration of the old South Shoebury parish (then being run by Shoeburyness Urban District Council), plus another chunk of Eastwood, the western half of North Shoebury and some small strips of Shopland and Great Wakering. Prittlewell, Leigh and South Shoebury were mature and independent self-governing towns when they were taken over; Southchurch, Eastwood and North Shoebury were largely unpopulated and rural. No other historic parishes have been annexed to Southend since the 1933 changes, although a number of modern parishes have been created within it.

The term 'Southend' is today used interchangeably for both the town (essentially the seafront and High Street) and the wider borough. The definition used throughout this book is the borough, now administered by Southend-on-Sea Borough Council (SBC), the county borough's successor. In addition to the historic communities, this area includes Westcliff and Chalkwell (both historically within the old Prittlewell parish) and Thorpe Bay (Southchurch). The northern

stretch of Eastwood and the eastern half of North Shoebury were not taken into the borough, so are out of scope for this book.

The buildings featured in this book come from all parts of the borough and date from the seventh to the twenty-first century. All exist at the time of writing. They are presented chronologically by oldest surviving structural component. Some retain their original use; others have been converted as required. Many of the older buildings, especially those which pre-date Southend town, have been adapted or extended as the town has grown. There is necessarily some subjectivity in their selection, but all have played a part in the story of Southend.

The 50 Buildings

1. St Mary the Virgin, Prittlewell

There is only one place to begin the story of Southend as told through its buildings: the parish church of St Mary the Virgin in Prittlewell. Not only was this the church for the parish at whose 'South End' the town began, it also contains fabric from the oldest surviving building in the Borough: the original Saxon chapel where worship started.

The parish structure of south-east Essex was set up by the Saxons by *c.* 700 and many local place-names are of Saxon origin. The discovery in 2003 of the grave of a possible Saxon king (*c.* 600–650) only a third of a mile to the north of the

St Mary the Virgin, Prittlewell, which contains fabric from the oldest surviving building in the borough.
The Saxon arch in the north wall of the chancel at St Mary's (inset).

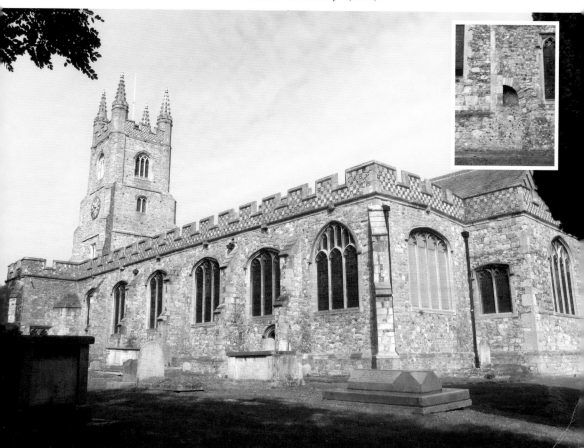

church shows that Prittlewell was an important Saxon settlement. Other Saxon graves were found when Priory Crescent was constructed in 1923.

The Saxons' chapel on the hill above this site is a typical location. A small part of it survives in the north wall of the chancel of the present church. This wall, and specifically an archway in it which is constructed of reused Roman bricks (no local Roman buildings remain), has been dated to potentially the seventh century by both architectural examination and archaeological excavation.

St Mary's is the only building in the borough with proven pre-Conquest components. Professor Stephen Rippon from the University of Exeter noted in a study of the local landscape he did for Essex County Council in 2011 that 'stone buildings in this period were extremely rare, suggesting that Prittlewell was a "minster" church of some importance.' This importance is underlined by the church being mentioned in the Domesday Book of 1086.

The overall building now looks nothing like the original Saxon church – that would have been a small, rectangular structure. It was largely replaced in the late eleventh or early twelfth century. A partial south aisle added later in the twelfth century was extended in the late-fifteenth or early-sixteenth centuries and a new south-east chapel constructed. The fifteenth century also saw the addition of the distinctive tower, probably completed c. 1470. A south porch was also added when the south aisle was completed. At over 150 feet in length, St Mary's is one of the longest churches in Essex.

The building's size and grandeur are due to the fact that medieval Prittlewell was a prosperous settlement, with a thriving market and fair. Until the late eighteenth century it was the largest settlement in the area now covered by the borough and the third largest in the Rochford Hundred – then the administrative area for the whole of south-east Essex – behind Rochford and Rayleigh. The Royal Commission on Historic Monuments (RCHM, 1923) described St Mary's as being 'of considerable architectural interest from its variety of styles'. The nineteenth-century Rochford Hundred historian, Philip Benton (1815–98), felt that it was 'the fairest and largest in the Hundred' and 'not to be surpassed by any in the county'.

2. St Laurence & All Saints, Eastwood

There was probably a Saxon chapel on the site of the parish church of St Laurence & All Saints in Eastwood, the adjoining parish to the north-west of Prittlewell, but nothing of that chapel remains. There is a strange stone in the floor of the current building which is suggestive of pagan worship possibly having taken place there even earlier than that.

The nave of St Laurence is nonetheless still very early. There is documentary evidence relating to Prittlewell Priory (see later) which states that there was a chapel at Eastwood c. 1110, so perhaps constructed c. 1100. It seems highly likely that this chapel is the nave of the present building, as that has been dated to the early twelfth century.

The *c.* 1100 chapel probably comprised just nave and chancel, an arrangement typical of early Norman buildings. The chancel has since been replaced, and the nave is hidden from external view by later additions so can only be fully appreciated from inside. Here can be seen the outlines of lost Norman windows and two ancient doors, dated from their ironwork to around the twelfth century and possibly original to the building.

As with Prittlewell Church, St Laurence has been significantly altered and added to over the centuries. The nave of the original building had its south wall pierced through in the thirteenth century to create a new south aisle and its east wall taken out to accommodate a replacement chancel. The lower part of the tower was also built in the thirteenth century (the upper part is modern).

In the fourteenth century the chancel roof was replaced and the north wall of the original nave was broken through to create a new north aisle. The nave and south aisle roofs date from the fifteenth century, when the latter was also raised. An unusual two-storey room was built at the west end of the north aisle in the fifteenth century; it appears to be where the priest prepared for services and possibly even lived. A small, red-brick porch was added to the south aisle in the sixteenth century.

St Laurence & All Saints, Eastwood.
The remains of Norman windows in the north wall of the nave at St Laurence (inset).

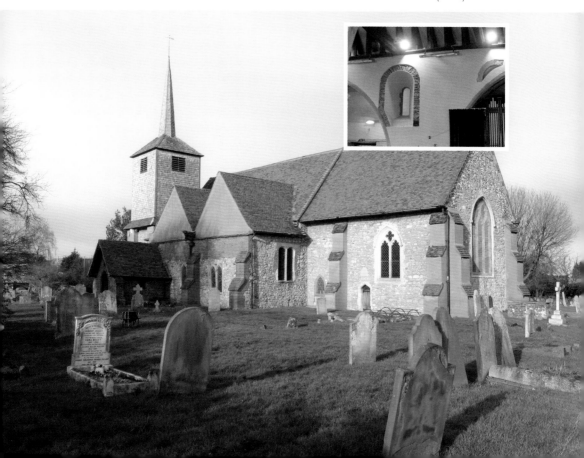

Benton found that 'in 1612 the church was in a dilapidated state' and that a rate was levied on parishioners to pay for repairs. After this the building remained largely unaltered until this section of Eastwood was annexed to Southend Borough in 1933. Eastwood was still then a predominantly rural and sparsely-populated parish. The village centre extended along Eastwoodbury Lane from St Laurence and the now-lost manor house of Eastwood Bury at one end to Cockethurst Farm (see later) at the other. The centre of twentieth- and twenty-first-century Eastwood has been refocussed some distance away around the junction of Rayleigh and Bellhouse Roads.

In 2001–03 parishioners faced a campaign by the owners of Southend Airport (see later) to move St Laurence 110 metres to the north-west to enable the airport to comply with new Civil Aviation Authority regulations. This proposal was rejected by Southend councillors, so a compromise was reached which included introducing level-crossing style barriers across Eastwoodbury Lane in front of the church. This arrangement lasted until 2011 when Eastwoodbury Lane was closed altogether, the runway was extended across it and the threat to the church – for the time being at least – went away.

3. St Andrew, South Shoebury

The most complete Norman building in the borough is the parish church of St Andrew in South Shoebury, a community which grew up in the very south-eastern corner of the old Rochford Hundred. This is only slightly later than St Laurence, dating from c. 1100–40. It contains classic Norman architectural decorations, which in this case have not been hidden from view by later extensions. What the visitor finds on arrival is fundamentally, as a c. 1990 church guide leaflet puts it, 'the most interesting and complete specimen of Norman architecture in the neighbourhood'.

St Andrew's survived later extension because when South Shoebury was developed after the arrival of the Army to set up Shoebury Garrison in the parish (see later), that establishment was constructed away from its historic centre. Development, when it came, emanated from there rather than from the church.

The RCHM dates the nave and chancel to the mid-twelfth century, slightly after the prevailing local documentary view of c. 1100–40. The c. 1990 guide leaflet states that the building 'was consecrated about 850 years ago', which would put that event at c. 1140. The church's website (accessed in 2015) says that people have worshipped there 'for over 900 years', which would give a date of pre-1115. Like Eastwood, South Shoebury church was granted to Prittlewell Priory in the twelfth century and its rectors were provided by the Priory.

Both nave and chancel have had thirteenth-century and later windows inserted. The east window dates from c. 1400. The twelfth-century chancel arch and north and south doorways are of classic Norman 'dog tooth' (zig-zag) design.

The parish's close connections with the nearby Thames Estuary are reflected in the church's dedication to St Andrew (a patron saint of fishermen), the carving of a net with a fish in it into the decoration of the south doorway and the boat depicted on the weathervane.

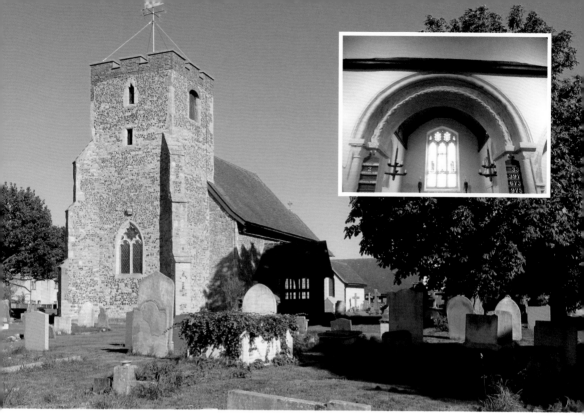

St Andrew, South Shoebury, the most complete Norman building in the borough.
Classic Norman zig-zag decoration on the chancel arch at St Andrew's (inset).

The tower was constructed in the early fourteenth century, though the top, red-brick part of it was added in the eighteenth century. The porch was added in the fifteenth century and the roofs of the nave and chancel were replaced at the same time. A restoration *c.* 1852 caused the loss of some 'interesting fittings and furniture and stained glass', but did not damage the fabric of the building. The vestry extension at the south-east corner was built *c.* 1902–03.

4. Holy Trinity, Southchurch

Holy Trinity Church in Southchurch – the parish between South Shoebury and Prittlewell – is also at heart a Norman construction.

The oldest part of the current building dates from *c.*1150, but there is evidence of a church in 823, when Southchurch was granted by a man called Leofstan to the monks of Holy Trinity in Canterbury. Sometimes the date 824 is given for the grant – local historian Alfred Goodale explained why in his book *Southchurch: The History of a Parish*: 'the recording of this gift in a list of benefaction to Canterbury occurred after a grant … in 823 and immediately before an entry under the date 824'.

The use of the name 'Sudcera' ('South Church') in the grant proves there was a church there at that time. The original building was probably wooden, and it

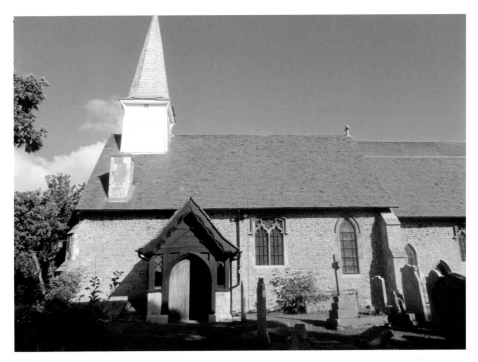

Holy Trinity, Southchurch.

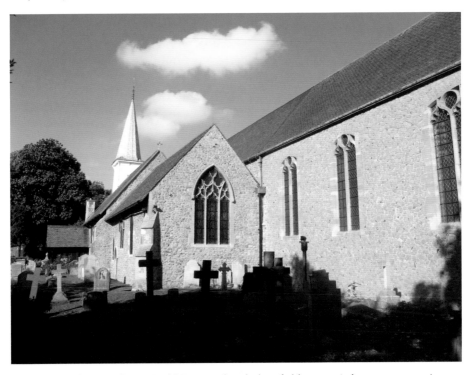

Holy Trinity, showing the original Norman church dwarfed by twentieth-century extensions.

might have been a 'minster' church like St Mary's in Prittlewell, serving a large territory before the local area was sub-divided into parishes. Professor Rippon theorised that south-east Essex was originally served by three minster churches: Prittlewell, Southchurch and Great Wakering (the last of these is outside the borough). If that is the case, Southchurch perhaps got its name because its church was the southernmost of the three.

The current building, whose dedication is presumably due to the Canterbury connection, features classic twelfth-century Norman windows and doorways, with typical zig-zag decoration around the latter. The chancel was probably added in the mid-thirteenth century and new windows were inserted both then and in the fourteenth century. Two thirteenth-century windows can still be seen in the south wall of the chancel. The timber belfry was added to the building sometime between the fifteenth and seventeenth centuries. The church was restored in the nineteenth century, when the south porch was also added.

Southchurch was historically a largely rural, agricultural parish. The village centre – a handful of buildings – was clustered around Holy Trinity and the White Horse pub (see later); most of the parish comprised isolated farms. This was the case until 1 November 1897, when the parish became the first outside Prittlewell to be annexed by rapidly expanding Southend. The original 'South End' fishing hamlet had been established close to the Southchurch boundary, so it was perhaps unsurprising that this was the first additional parish to be taken into the Borough. The impact on Holy Trinity was significant.

The original building was drastically altered in 1906, when a new north aisle was built to accommodate the massive population growth which followed annexation. This new aisle was so big that in practice it became the nave of a new church, with the original building being relegated to the role of south aisle. The original building's north wall was replaced by an arcade of columns, through which space the two structures were connected. Some of its features were moved around within the new structure: the mid-twelfth-century north doorway was reset into the west wall of the new extension, and a mid-twelfth-century window and two fourteenth-century windows were reset into the new extension's north wall.

The 1906 extension was given a new chancel in 1931 and these two structures now dwarf the original building.

5. Prittlewell Priory, Prittlewell

Churches were not the only religious buildings in the area. In Prittlewell the importance of the original Saxon settlement was underlined during the Norman period with the construction of Prittlewell Priory, the only historic religious complex in the whole of the modern borough.

The priory was founded sometime between 1086 and 1121. The traditional date given for it is *c.* 1110. This was the year in which Prittlewell's then Lord of the Manor, Robert de Essex, is believed to have given a grant of land to the Cluniac Priory at

Prittlewell Priory, the only ancient religious complex in the borough.

Prittlewell Priory, showing the recently restored nineteenth-century additions.

Lewes in Sussex for the establishment of a priory in the parish. Lewes was home to the first Cluniac Priory in England and the English headquarters of the movement.

Robert's father Sweyn (sometimes 'Swein') is listed as Lord of the Manor in the Domesday Book of 1086, so the grant by Robert must have taken place after that. The date of *c.* 1110 was apparently seen in a document by one of the earliest English historians, Richard Newcourt (d. 1716), but that document has disappeared. The oldest surviving document to mention Prittlewell Priory dates from 1121, so it must have been founded before that.

The first Priory buildings were made of wood and none of those has survived. The oldest part of the surviving buildings is the north wall of the refectory (seen on the left in the first photograph), which dates from *c.* 1180.

Excavations have shown that there were many priory buildings and that their construction probably took place piecemeal, starting with wooden structures and progressing to stone as funds allowed. The first building was probably a small oratory. Eventually the completed priory included a church and cloisters, a chapter-house, chapels, refectory and cellars, numerous outbuildings and some fishponds. The whole complex may have been enclosed by a wall to keep the monks who resided there secluded from Prittlewell villagers.

The priory was dissolved by Henry VIII in 1536 and shortly after that most of the buildings, including the believed 200-feet-long priory church, were pulled down, leaving only the refectory, cellars (*c.* 1200) and the fourteenth-century prior's chamber standing.

The first private owner was Thomas Audley. In subsequent centuries residential accommodation was added to the west and south-west fronts as the surviving priory buildings were converted for domestic use.

In 1917 R. A. Jones, a wealthy local benefactor, bought the surviving buildings and their surrounding grounds for conversion into a museum and public park. This new 'Priory Park' opened in 1920. The museum opened in 1922 and the buildings have been used for that purpose ever since. A major restoration of the surviving buildings was carried out in 2011–12. They were formally reopened on 16 June 2012 by comedian Phill Jupitus.

6. St Mary the Virgin, North Shoebury

It was while Prittlewell Priory was flourishing that the parish church of St Mary the Virgin at North Shoebury, one of the easternmost historic parishes in the borough, was built.

St Mary's is predominantly thirteenth century, but there was an earlier church on the site which is referred to in twelfth-century Prittlewell Priory documentation: its grant to the Priory was confirmed then by Thomas Becket. The late twelfth-century font in the church may well be from that earlier building. The Priory's monks were perhaps responsible for the construction of the current building, thought to be the third to stand on the site.

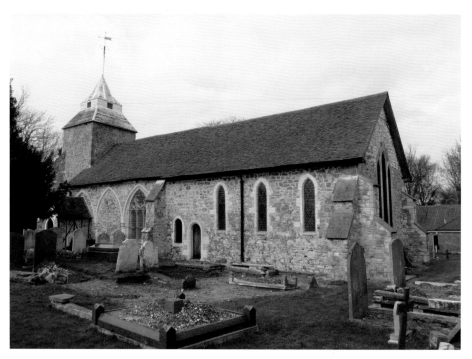

St Mary the Virgin, North Shoebury.

The oldest part of the current building is the chancel, which dates from *c.* 1230 and features six original lancet windows and a contemporary doorway through the south wall. The chancel arch, though, may date from the following century. The nave is either the same date as the chancel or slightly later.

The south wall of the nave was pierced through with three arcades *c.* 1250 and a south aisle was added. This aisle was demolished at some uncertain date and the arcades were filled in. Three arches showing where the aisle stood can be seen at the left in the photo, by the porch.

The lower part of the tower is late thirteenth century and features a gothic arch to the nave. A contemporary lancet window exists in the west wall of the tower.

In around the mid-fourteenth century the north wall of the nave was rebuilt. The glass in the windows on this side dates from this period. The top stage of the tower was added or rebuilt either around this time or in the fifteenth century, when the nave roof, still featuring a king post design which is typical of the period, was renewed.

The rubble infill of the middle arcade bay from the lost south aisle appears also to date from the fifteenth century, suggesting that the south aisle was still there at this time. The infilling of the other bays was apparently carried out later. Some gravestones immediately to the east of the porch, where the aisle would have stood, date from the eighteenth century, so it must have gone by then.

The church porch was erected in the eighteenth century and incorporates reused, possibly seventeenth-century, floor tiles.

The church was restored *c.* 1884–85, apparently partly under Benton's supervision.

St Mary's has remained small and largely unaltered over the centuries due to North Shoebury's late annexation by Southend (1933).

7. Southchurch Hall, Southchurch

Apart from religious establishments, the other major high-status buildings in local medieval society were manor houses. The feudal system then in operation organised lands into 'manors'. These were overseen by a lord of the manor (such as Robert de Essex in Prittlewell) whose house, usually a large, impressive one, was the manor house and headquarters of the unit. Many of these have been lost locally, but several survive. The oldest is Southchurch Hall in neighbouring Southchurch, which is also the oldest surviving secular (non-religious) building in the borough.

The oldest parts of the current structure date from *c.* 1321–64, but references on site and in old guidebooks suggest it could potentially be earlier. Leonard Helliwell, who wrote a guidebook to the building in 1969, noted that although the roof of the central and oldest part of the house – the great hall – 'has generally been accepted

Southchurch Hall, the oldest surviving secular building in the borough.
The Great Hall at Southchurch Hall (inset).

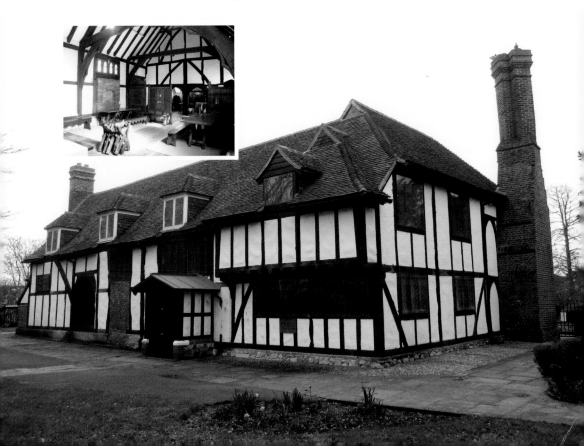

as about 1340, detailed investigation into types of joints used in carpentry work has led Cecil A. Hewitt [an expert in the field] to suggest an earlier date of the last quarter of the thirteenth century'. He adds, however, that while 'it is believed that erection was started during the lifetime of Sir Richard de Southchurch ([Lord of the Manor] *c.* 1275) ... specialist opinion leans more towards a general date of the first quarter of the fourteenth century'. The current guidebook and exhibition material put the dates at *c.* 1321–64; the exhibition describes the building as being 'rebuilt in the form we know it today' during those dates.

Southchurch Hall is a medieval hall house – a rare survivor typical of the period, with its central great hall forming the core of the building and being added to in later periods, notably in this case during the Tudor and early Stuart era, and following extensive restoration in the late 1920s and early 1930s when the building was presented to the town by the executors of Thomas Dowsett, the first mayor of Southend.

In Helliwell's view 'it is beyond doubt that the present Hall is not the first home on the site'. He adds that 'it is not known when the moat [a defensive structure encircling the building] was cut' but 'it is believed (although there is no present evidence to support the claim) that it is of Pre-Conquest origin. Certainly, however, it pre-dates the present building, as foundations of an earlier structure were revealed during the restoration of the Hall in 1929/31'.

The remains of a gatehouse can be seen below the bridge over the moat to the north of the Hall. The sites of various other lost outbuildings have been located by excavation and are referred to in a 1391 inventory. These include a chapel dedicated to St Katherine, which stood in part where the exhibition and sales room is now (south-eastern 1929–31 extension), and which, says Helliwell, 'certainly existed (or was about to be built) at Southchurch Hall in the year 1275'.

Owned by the monks of Holy Trinity, Canterbury from *c.* 823 to the mid-sixteenth century, the Manor of Southchurch was tenanted for much of the twelfth–fourteenth centuries by the de Southchurch family, of whom Sir Richard was perhaps the most notable member, serving as Sheriff of Essex and Hertfordshire in 1265–67.

The current building was ransacked during the Peasants' Revolt (1381) and various records housed there were destroyed at this time. After the Dissolution of the Monasteries in the mid-sixteenth century the building was occupied by Richard, Lord Rich. By the time of Dowsett's ownership, the Hall was in use as a farmhouse, but much of the surrounding estate had been sold off for development. After restoration *c.* 1929–31 it was for many years a public library. It is now a museum.

8. Fox Hall, Shopland

Another fine house from this period is Fox Hall, the only significant historic building in the strip of Shopland parish which was incorporated into the borough in 1933.

Fox Hall, the oldest building in the strip of Shopland parish which was incorporated into Southend Borough in 1933.

Fox Hall from the west, showing the sixteenth-century chimney.

Dr P. H. Reaney, in his authoritative book *The Place-Names of Essex*, writes that the name 'Fox Hall' is 'probably to be associated with the ... [family] of ... Thomas le Vaut (1327 SR) [SR = Subsidy Rolls, the source of Reaney's information]'. The British Listed Buildings (BLB) website (which does have errors in it) agrees that the building had its origins in the fourteenth century. Most pertinently, an access statement prepared by surveyor Peter Richards for the building's current owners, the Norman Garon Trust, during a re-roofing in 2006 states that 'the hollow chamfered braces, arched service doorway and the reused sooted roof timbers all confirm the C14 date'.

Apart from the surviving fourteenth-century elements, the building dates predominantly from the fifteenth and sixteenth centuries, when it was evidently substantially rebuilt. It is of classic Essex design for a domestic dwelling in the period between then and the Victorian era: a two-storey structure of timber-framing and weatherboarding, with a tiled roof.

The cross-wing at the east end of the house (the left-hand end in the photographs) and the adjoining eastern end of the main block are the oldest visible parts externally. The RCHM states that these are 'the remains of a fifteenth-century building, the west end of which was rebuilt in the sixteenth century'. The upper storey of the fifteenth-century cross-wing projects on the south side. A sixteenth-century chimney stack adjoins the western end of the building. Richards felt that its fourteenth-century origins and fifteenth- and sixteenth-century additions meant that 'the house retained a high status through the post-medieval period'.

Inside the building when the RCHM assessor visited (1923) there was evidence of a blocked doorway in the west cross-wall between the cross-wing and the part of the structure erected during the sixteenth-century rebuilding. There were also two curved braces, like those supporting the projecting fifteenth-century upper storey, which 'probably supported the tie-beam of the original hall roof'. A sixteenth-century fireplace was also visible inside. The cross-wing retained an original tie-beam.

The BLB found that the whole building was re-roofed in the late seventeenth or early eighteenth century and, as mentioned above, this was done again in 2006. There is also a small modern addition at the east end of the building.

When the author of this book first visited Fox Hall in 1994 it was boarded up and derelict. Fortunately, however, the creation of the Garon Leisure Park nearby in 1993–96 and the establishment of an equestrian centre, tennis facility and golf course on land at Fox and Shopland Halls led to the building being restored. By the summer of 2000 it was inhabited again, although divided into two separate dwellings.

During construction of the golf course clubhouse, builders for the Trust uncovered a spring which, combined with two surviving ponds to the immediate north and east of Fox Hall, suggests that, as with Southchurch Hall, there may once have been a moat around the building. Archaeologists also found evidence of a 'street' leading towards the now-demolished Shopland church.

9. Swan Hall, Prittlewell

Neighbouring Prittlewell was at its peak in the fifteenth century: the parish church was massively enlarged and the village had a thriving market and fair. The settlement's prosperity is reflected in the secular architecture of the period, seen at its best in the beautifully restored Swan Hall, which stands opposite the church in Victoria Avenue and dates from *c*. 1407.

In the late twentieth century Swan Hall was known as 'The Carlton Bakery' but a devastating fire in 1998 brought the bakery business to an end. The building was bought by local restoration expert, Malcolm Ginns, who researched its history and restored it to how it might have looked in the medieval period. Malcolm has kindly shared his findings with the author.

During the restoration ten samples from the building's timbers were sent to the University of Nottingham for tree-ring analysis; seven came back with a date showing that the trees they came from had been felled in 1407. Construction probably took place shortly afterwards while the timber was still 'green' and able to be easily shaped.

The restored building was unveiled in 2004. Malcolm has told the author that 'the bulk of the framing is still original, including the shop front and first floor

Swan Hall, showing (at left) the 2015 extension and (white building, far right) Nos 269–275 Victoria Avenue, another fifteenth-century building; this area was the commercial heart of medieval Prittlewell.
Swan Hall, pictured before extension in 2015 (inset).

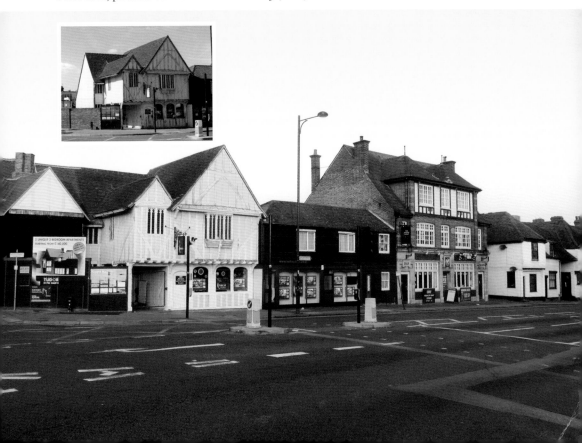

studwork, although the stunning windows are facsimiles accurately restored from fragments that thankfully remained in situ'. A cantilevered timber, wattle and daub chimney stack at the rear of the property is believed to be unique.

The quality of the timber framing and the location of the building in the centre of the village suggests that it was probably of high status. It may originally have had a shop or other commercial premises on the ground floor which was partly open to the road. There was accommodation behind this shop and an open hall on the floor above. Prittlewell's market ran from the thirteenth to sixteenth centuries and this building may well have been owned by a prosperous local merchant, or possibly even served as the village's market hall. By the early seventeenth century the building was, however, being used as the Swan public house. Its twenty-first-century name, 'Swan Hall', has been chosen to reflect these former roles. The presence of a probable padstone – a stone used to spread a concentrated load – suggests that there might even have been an earlier building on the site.

While this book was being written Swan Hall had an extension built to the south, facing West Street. This extension houses five two-bedroom flats, which went on sale in the summer of 2015.

Twenty yards north of Swan Hall, at Nos 269–275 Victoria Avenue, stands another fifteenth-century building which probably had a similar commercial function. According to the *Yellow Advertiser* newspaper (20 January 1989, when the building was being restored), it dates from 1475. However, the *Standard Recorder* of 21 July 1989 described it as 'dating back to 1450'.

10. South Shoebury Hall, South Shoebury

Another impressive building which has its origins in this period can be found in South Shoebury: the former manor house of South Shoebury Hall, which stands to the east of St Andrew's Church. The manor had its origins in the twelfth century, when the estate on which the house now stands was given to Prittlewell Priory by the latter's founder, Robert de Essex. The oldest part of the current building, however, dates from *c.* 1450.

The existing structure seems to have begun life as a 'longhouse' and to have been added to over the centuries. The longhouse survives in part as the middle section of the much larger current house. The current owner has informed the author that the *c.* 1450 date has been arrived at from the study of a surviving ladder staircase which is typical of the period.

In the 1530s the building was owned by Richard, Lord Rich. After his death the original building was extended to provide more space. Maureen Orford, in *The Shoebury Story*, and Judith Williams, in *Shoeburyness: A History*, both date this event to 1568. Lily Jerram-Burrows, a local historian who visited the building in 1977, noted that the entrance room on the ground floor on the north side had 'a curious flooring of Dutch cobbles which came to this district as ballast in some of the barges sailing from Holland many years ago'.

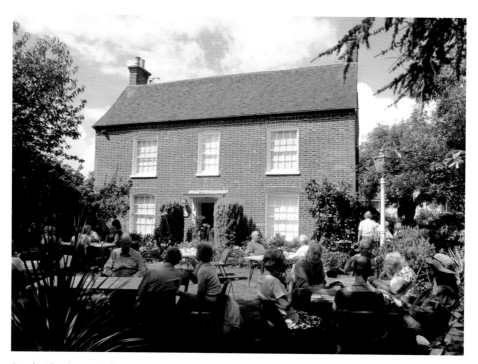

South Shoebury Hall pictured during a National Gardens Scheme open day, showing the eighteenth-century frontage.

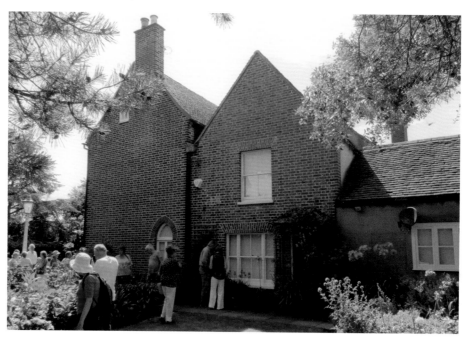

South Shoebury Hall, showing the red-brick eighteenth-century section and the yellow-brick nineteenth-century rebuild of the original part of the house.

The building was altered again in the 1760s, with the addition of a large and impressive red-brick extension to the south by the then owner, Thomas Parsons. This effectively relegated the Elizabethan/longhouse building to the status of the rear part of a much enlarged house.

The original building – the rear part of the enlarged one – was remodelled during the Victorian period and rebuilt in yellow brick.

Benton records details of a major fire at the property in 1861, at which time it was being operated as a farm. He reports that 'the whole of the buildings with the exception of the house and a stack, fell a sacrifice to the flames'. Soldiers from nearby Shoebury Garrison came to assist, but some, evidently deliberately, made the situation considerably worse. Perhaps as a consequence of these troubles, the building was put up for sale in 1866. The sale particulars refer to 'new farm buildings', presumably constructed as a result of the fire.

Jerram-Burrows found that the building was twice saved from demolition in the twentieth century by Captain and Mrs Townend, who leased it from 1929 to 1974, in which the latter year the then widowed Mrs Townend bought the freehold. The nautical weathervane on St Andrew's Church next door was erected in the captain's memory. The building was restored in the late 1980s.

In the grounds of the hall is a small, circular, single-storey brick building with a tiled conical roof known as the 'Garden Room'. This may date from the late eighteenth century, but seems more likely to be early-nineteenth.

11. St Clement, Leigh

At the other end of the borough from South Shoebury was the established maritime community of Leigh. Here, the houses, pubs and shops of the main village were huddled together along the shoreline on the northern bank of the River Thames, while inland on the hills above it there was a handful of scattered farms. Above it too, was the parish church of St Clement. This dates predominantly from *c.* 1450–1510, but was greatly extended in 1872, 1897 and 1913 as the population grew following the arrival of the railway in the 1850s.

John Bundock, who wrote a comprehensive account of the building in his 1978 book *Leigh Parish Church of St Clement*, traced the evidence for a church on the current site to only around 1300, which is surprisingly late. He mused that 'as there is no evidence of a church on the present site before about 1300 one is led to ask if there might not have been an earlier church in the Old Town [the maritime village below it] of which nothing now remains and which was discarded in favour of a new one on the present site'. No trace of a church in the Old Town has yet been found, however, and, in his companion book on *Old Leigh*, Bundock further adds, somewhat definitively, that 'there is no evidence of there ever being an ancient church in any other part of Leigh'.

Bundock found that 'nothing whatever now remains of any part of the church before the fifteenth-century building except the bowl of a piscina found in a wall

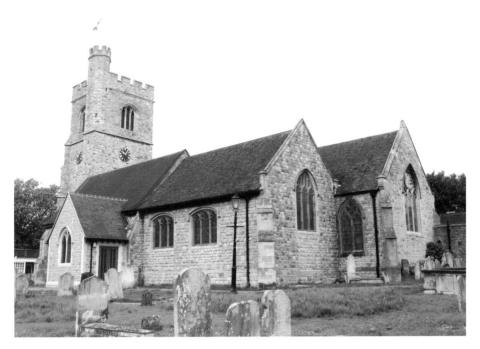

St Clement, Leigh.

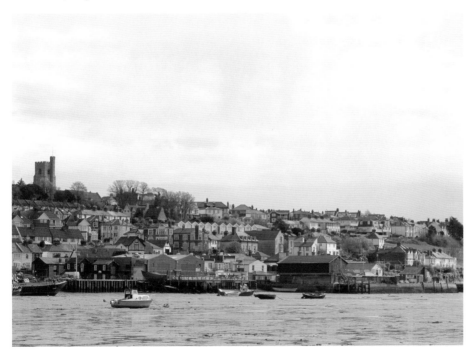

Leigh from Two Tree Island, showing the prominent position of the church.

during the work done in 1913'. He did, however, unearth some paintings and photographs from before the 1872 rebuilding, which extended the chancel, and found in studying them that the east window depicted there was 'of the decorated period – about 1300, showing that at least some of the chancel was originally of that date though nothing of it now remains'. Bundock laments that no excavations have taken place at St Clement's, as this means that 'we are therefore kept in ignorance of the existence of any church on the site before the fourteenth-century chancel which no longer exists'.

The predominantly fifteenth-century building that survives is nevertheless of significant interest. The north aisle, nave and tower are the oldest parts, dating from *c.* 1450–1500. The north aisle contains a blocked-up doorway which appears to have been filled in shortly after construction. The red-brick Tudor porch is only slightly later, dating probably from *c.* 1500–10. It originally had battlements.

In the sixteenth and seventeenth centuries Leigh was a major port and shipbuilding centre. The church's hilltop position made it a landmark for sailors. Several Leigh sons grew up to be captains or admirals in the Navy and many are commemorated by brasses and monuments in the church. The oldest of these is a brass to Richard Haddock from 1453 which can be found on the floor in the north aisle. There is also a tantalising inscription on a memorial to Robert Salmon, who died in 1641, which states (in translation to modern spelling) that he 'was interred with his ancestors of about 300 years' continuance in the grave of his father in this chancel'. This appears to confirm Bundock's suspicions of an earlier church. The rectors' board gives the incumbency of the first known rector as 1248, which also supports this theory.

12. Porters Grange, Prittlewell

Roughly contemporary with St Clement's church is Porters Grange, now the mayor's parlour. Usually known as 'Porters', it is named after the le Porter family, who owned the estate in the fourteenth century. John W. Burrows and George Jennings, joint authors of a booklet published in 1934, found that 'it was called Porters as early as 1471'. The current building was probably constructed in the late fifteenth or early sixteenth century.

The last private owner of Porters was a well-known architect, Sir Charles Nicholson, who found its construction history to be 'very puzzling' – a confusion of juxtaposed dates and materials. Theories for this include: the original construction work being stopped and restarted; the use of old designs in new work; or the reuse of older material from elsewhere. The Visit Southend website states that 'the character of some of the windows, the decoration on the fireplaces, and the panelling in the hall [one of the principal downstairs rooms], indicate a date between 1475 and 1506'.

The hall has linen-fold panelling incorporating five early-sixteenth-century panels of faces, thought to be French. Nikolaus Pevsner dates them to *c.* 1535 in

Porters Grange, home of Southend's mayor.

The Macebearer's Cottage at Porters.

his famous *Buildings of England* series. They may have come from a shipwreck or another local building. The RCHM dates two of the windows in the hall to the late sixteenth century.

The Porters estate was for a long time owned by the Tyrrell and Browne families, passing from one to the other *c.* 1506. The latter had connections with the Lord Mayor of London. Porters appears on John Norden's 1594 map of Essex, which features comparatively few named buildings other than churches.

The BLB records that the central part of the house was substantially rebuilt at the end of the sixteenth century. The RCHM agrees that 'it was completed or extensively rebuilt' then. Burrows and Jennings write that 'the Tyrrells may have started the work and the building [was] completed by the Brownes'. They add that Humphrey Browne (d. 1592) was probably 'the owner responsible for the greater part of the later constructional work'.

In 1868 the estate was sold. Much of the land was developed, but fortunately the house was retained. Sir Charles Nicholson bought it in 1912 and sold it to the local authority in 1932 to ensure its preservation. It became the mayor's parlour three years later.

Porters contains photographs of all of Southend's mayors. The chair in which the mayor sits to have his/her official photograph taken is kept in the hall. According to the local authority minutes from 9 August 1893 this chair appears to contain a little-known secret:

> Mr Edward Wright, of this Borough, Architect, presented to the Corporation a carved oak mayoral chair made from English oak and used in the construction of the first Southend Pier [see later]... it was resolved unanimously that ... a memorandum of the presentation thereof now signed by the Donor and the Mayor, Aldermen and Councillors present, be deposited in the chair.

In the grounds of Porters stands the Macebearer's Cottage (formerly 'Porters Grange Cottage') – the home to the Macebearer for SBC. Keith Holderness, Macebearer 1989–2012, has researched its history and kindly made this information available to the author.

Keith obtained the opinion of an English Heritage surveyor, who dated the cottage to the late sixteenth century. Keith also found that it was originally split into three sections: a brew house, now a garage; one-up, one-down living quarters; and stables, now also living accommodation. It seems likely that the building was converted into accommodation when Porters was purchased by SBC. The Macebearer at the time, Ernest Turner, moved into it with his wife Frances in 1936.

13. The Bellhouse, Eastwood

The oldest surviving secular building in Eastwood is The Bellhouse inn. The RCHM describes it as having been 'built in the sixteenth century on an L-shaped

plan with the wings extending towards the S. and W. and a staircase in the angle'. Later additions have changed the size and shape of the original building.

The Bellhouse was originally a farmhouse, conveniently located next to Eastwood Brook on the main Rayleigh–Eastwood road, near the junction of the road to Leigh. The name is said to come from the hourly ringing of a bell at the property to guide travellers through the woodlands to the east of Rayleigh from which Eastwood itself got its name. The Essex Record Office (ERO) holds a copy of an estate map of Bellhouse Farm from 1790. It appears then to have been in the ownership of Richard Acave. The farm's lands extended to the other sides of what are now Bellhouse and Rayleigh Roads, and even beyond what is now Green Lane. There was extensive woodland at the southern end of the estate around the area now occupied by the A127. The estate included stables and orchards.

The Eastwood Tithe Award of 1840 lists Sir Thomas Neave as the owner and Ann Lucking as the occupier. (Following the passing of the Tithe Commutation Act in 1836 every parish was assessed for the rental value of individual properties. A Tithe Award and accompanying Tithe Map were consequently produced for each parish.) Benton, writing in 1867, found that the building belonged to the Neave family throughout much of the nineteenth century.

In July 1872 Bellhouse Farm was put up for sale. It was described as 'well situate, abutting upon good roads'. Someone has written on the copy of the sale

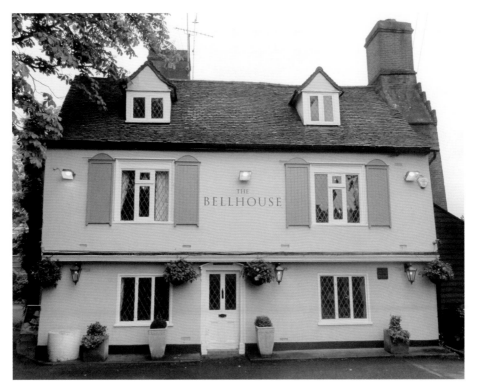

The Bellhouse public house, Eastwood.

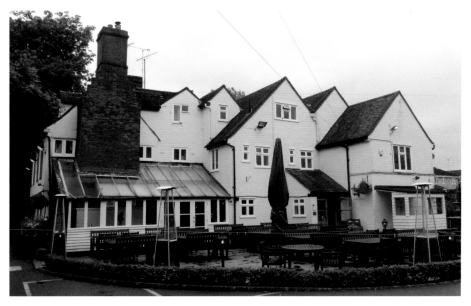

The Bellhouse, showing its multiple-gabled roof.

particulars held by the ERO that it was in 'bad repair'. The estate was marketed as being in easy reach of local towns and the railway at Leigh. The sale included two other 'homesteads' and 121 acres of land. Bellhouse Farm itself had four bedrooms, an attic, two parlours, a kitchen, pantry, scullery and dairy, and a detached coal shed and brewhouse. A map accompanying the sale shows that twenty of the fields depicted in the 1790 map had been merged into just three large ones by 1872. Most of the woodland shown in 1790 had been grubbed out and converted into fields.

Bellhouse continued as a farmhouse into the twentieth century, but by then the farm's lands were being sold off for development. By the 1920s a portion of the land was being used for brick-earth extraction; the small brick office building for this venture still stands nearby. Those brickworks continued to operate until the early 1970s and were a significant local employer. The business was run by the Cornish family, who occupied Bellhouse Farm itself during the middle part of the twentieth century. The Cornishes later sold the farmhouse to Mr Iles, a local dentist.

In 1970 the building was converted into a public house by Courage Brewery and it has since been greatly enlarged.

14. The Crooked Billet, Leigh

A public house of probable similar age can be found next door in Leigh. The Crooked Billet in the High Street there is one of the few buildings which survives from when Leigh was at its peak as a port and shipbuilding centre. Many were demolished when the railway arrived in the 1850s or post-1945 when they were either declared

unfit for human habitation or were in the way of a proposed (but never completed) 'Road to the West' scheme from Southend. Leigh retains the character of a historic working village, but most of its buildings are nineteenth century or later.

Displays in Leigh Heritage Centre (LHC) describe The Crooked Billet as Tudor and built *c.* 1500. The Leigh Old Town Conservation Area Character Appraisal describes it as 'reputed to have been built in the sixteenth century' and cites the steeply pitched roof as an indicator of this. Staff working at the pub when the author visited thought it was more likely to be *c.* 1650. The ERO has deeds for it dating back to 1678. The LHC suggests it was once the residence of Captain John Rogers (1618–83). The left-hand bar contains what looks to be genuine timber-framing, but that could date from any of the above periods.

Many of the Billet's original features have been lost, most dramatically when the back portion was removed when the railway was constructed. The BLB notes that it contains eighteenth-century features, was re-fronted in brick in the nineteenth century and was given concrete roof tiles in the twentieth. The RCHM describes it as 'much altered and added to'.

When the railway arrived the pub was owned by the Chelmsford brewery company, Wells & Perry, and occupied by Ann Johnson and Isaac Watts. It appears to have had earlier connections with the Haddock family, referred to under St Clement's Church. This Haddock connection has compounded the problem of dating the building. Judith Williams, in her book *Leigh-on-Sea: A History*, writes that the Haddocks lived in what is now Billet Lane (which, pre-railway, was a

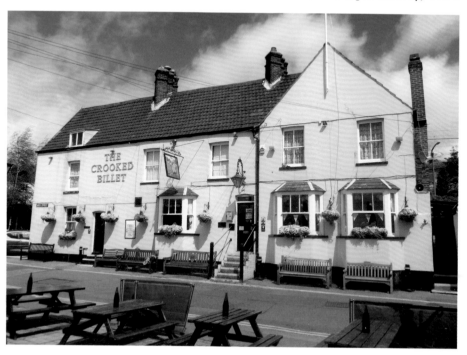

The Crooked Billet, Leigh.

major local thoroughfare that extended uphill from the immediate west of the pub) from the fourteenth to the eighteenth century and that in 1430 they had a house there called 'The Old Billet'. The lane took its name from this residence. In 1707, writes Williams, the Haddocks' residence was converted into a beerhouse. When this was demolished its licence was transferred to an also now-demolished pub called The Coal Hole, which stood immediately west of The Crooked Billet, on the other side of Billet Lane. Some sources mix up all these different buildings into one.

In 1988 the Billet was refurbished by its then owners, Taylor Walker. The timber-framing in the left-hand bar, and associated plasterwork, were revealed at this time.

Billet Cottage, further up Billet Lane on the other side of the railway, is also of interest. It bears the date '1620' on a modern sign, but the owner has informed the author that it is actually *c.* 1720. That building remains largely original and appears to have been constructed from much older materials, possibly including ships' timbers. The oldest timbers have been dated to the fourteenth or fifteenth century.

East of The Crooked Billet stands Nos 62–63 High Street. The BLB describes this as mid-sixteenth century. Carol Edwards, who researched it for her 2013 book *The Old Town: Leigh-on-Sea*, writes, however, that it was 'originally two cottages made of lathe and plaster frames, constructed in 1600'. In the mid-nineteenth century this building was also a pub, initially The Trowel & Hammer, later The United Brethren.

15. North Shoebury House, North Shoebury

At the other end of the borough, North Shoebury House in rural North Shoebury also appears to have sixteenth-century origins. It additionally has a special place in the annals of local history as the birthplace of Philip Benton (1815), author of *The History of Rochford Hundred*. Sadly, Benton never completed his North Shoebury volume, but it was updated and finished by Jerram-Burrows, in 1981.

At first glance the building looks eighteenth-century, with a typical red-brick Georgian frontage. However, behind the façade it seems there lurks a much older house.

The building's owners have informed the author that they understand that the oldest part – a small sitting room facing the rear courtyard – dates from *c.* 1560s and was built using ships' timbers. The ground floor here is built around a courtyard with a well in it. Two long barns have been incorporated into the main house, making a C-shaped footprint. Benton found evidence that the land on which North Shoebury House stands was first mentioned in 1591, though he makes no reference to any building.

The ERO holds a number of tenancy agreements for the building, the earliest dating from 1619. An estate map from 1703 shows an unnamed building exactly where North Shoebury House stands. It is described as being owned by 'Miss Luci Chedwick'.

North Shoebury House, birthplace of Philip Benton.

Benton notes that the building's late eighteenth-century owner, John Ibbetson, who inherited it in 1768 and died in 1804, 'is said to have improved the residence at Shoebury by bricking the front of the house, whilst his tenant, C. [Christopher] Parsons [d.1787], built additional rooms at the back'. Parsons was also tenant to the previous owner, John Milne, c. 1763 to 1768. Williams records that the property was sometimes called 'Bricked House' as a result of Ibbetson's frontage (it is named as that on the 1849 Tithe Map for North Shoebury). The owners advise that almost all of the building is timber-framed: 'even the brick front which was added to the front of the house by John Ibbetson in the 1760s is over a timber frame.'

Ibbetson left the property to his sister, Elizabeth Jones, who lived in London but had apartments at the building which she used to visit about once every four years for a month's stay. Benton notes that 'the country folks had great reverence for her'.

Benton's parents were tenants of the property during Jones' ownership. His father, Samuel, was a prosperous local farmer. Philip lived at North Shoebury House twice – once as a youngster and again in the late 1880s. His sister Mary married the well-known local naturalist, Christopher Parsons (1807–82, a descendant of his namesake above). Benton and Parsons met regularly to exchange knowledge of the area's history and wildlife.

Jerram-Burrows records that the property was owned by the Hutley family 1891–1937 and from 1977 until at least the date of publication of her book. In the middle part of the twentieth century it was, she says, owned by local farmer, Caleb Rayner. Some sale particulars for the building from 1935 (two years after

the parish's acquisition by Southend) make much of its land's 'considerable prospective building value' and as a resource for brick earth.

Jerram-Burrows credits Paul and Rosemary Hutley, who owned North Shoebury House when she was writing, with uncovering the early history of the building. They 'have spent much of their time… restoring it to its former appearance', she writes, and 'in so doing they have unearthed evidence that the property is much older than was previously thought'. She does not provide a date to accompany this statement, but it may be where the *c.* 1560s date originated. One of the barns at North Shoebury House may be late seventeenth century.

16. Cockethurst, Eastwood

At the beginning of the seventeenth century Eastwood too was largely agricultural. Apart from The Bellhouse, the only other surviving farmhouse from this period is Cockethurst.

Cockethurst appears to have been built by John or Samuel Vassal *c.* 1603 from existing ruins or foundations. John is the first named owner of Cockethurst; Samuel, his son, would have been only seventeen at the time, so the former seems more likely. The Vassals (sometimes 'Vassalls') were a wealthy French Catholic family who moved to England to escape religious persecution. John Vassal was

Cockethurst, Eastwood.

a London merchant and alderman who owned ships which fought the Spanish Armada. He also owned a *Mayflower*, which may or may not have been the ship which took the Pilgrim Fathers to America in 1620, stopping in Leigh on the way. Samuel had a varied career, being jailed for refusing to pay ship taxes, serving as an MP for the City of London and providing ships for the Parliamentarians during the Civil War. In 1628 he was named in the first charter of the Massachusetts Bay Co. and granted a portion of the Massachusetts Bay Colony's land.

The original building had two rooms on each of its three floors. The southern of the ground floor rooms is called 'the sailcloth room' because it has a ceiling made of sailcloth; the current ceiling was made in Leigh by traditional sailmakers. The ceiling in the ground floor hallway is believed to have once had a trapdoor in it, with a rope ladder hanging down which could be retracted at night to prevent intruders from gaining access to the upper floors.

Around 1730 an extension was erected at the back of the building, with a new room added behind the sailcloth room and a passageway and proper staircase added behind the hall and other ground-floor room. A brick 'skin' was applied to the original exterior, thickening the walls. A further addition was made to the north *c.* 1810–30, with the construction of a dairy, now the kitchen.

Cockethurst passed by marriage to the Wren family in 1808. William Weld Wren was owner in the 1840s and 1850s.

In 1928 the farm was put up for sale and described as being 'ripe for immediate development'. It had 63 acres of land, 22 of which were said to contain 'valuable brick earth deposits'. The farmhouse itself was described as possessing a 'morning room', drawing room, dining room, kitchen, pantry, larder, scullery, wash-house, 'boothole' and cellar. There were four large bedrooms on the first floor and three more on the second. Outside there was the dairy, a store shed, lawns, an orchard and flower, fruit and kitchen gardens, plus numerous outbuildings.

The farm appears to have been owned from then until 1980 by the Fowler family: initially John Thomas Fowler, a farmer, councillor and JP, and his wife Orana, and then their four unmarried daughters. It is believed that Mr Fowler came to Cockethurst in 1910 to work there as a tenant farmer.

After the last daughter died in 1980, the building served as the Cockethurst Manor Hotel. However, the *Yellow Advertiser* of 20 September 1985 reported that SBC wanted to purchase it for use as a civic building and had written to Michael Dukakis, governor of Massachusetts, to ask for financial help. The council had already declined an application to convert it into a pensioners' complex. The newspaper also reported that an 8-feet-square priest hole, accessible only from the attic, had been found in the building. A later plan for the construction of eight houses on the site of the outbuildings also never came to fruition.

At least one of the surviving outbuildings appears on a plan from 1755. A second also looks like it appears, but the existing building on the site looks more modern. Cockethurst has three other outbuildings: elements of those could also be eighteenth century.

17. Leigh Park Farm, Leigh

In neighbouring Leigh, far inland behind the cliffs above the original port, the majority of the parish was also populated only by farms. Most of these have been built on, but the original farmhouse for one of them, Leigh Park Farm, survives as a residential conversion at Nos 71–73 Olive Avenue.

Williams found that the farm existed in 1619, when it was leased to William Carpenter. She also found that from *c.* 1750 it was owned by the Johnson family for the next hundred years. The ERO holds an estate map of the farm, showing individual fields, which dates from *c.* 1775, and the will of William Prior Johnson which dates from *c.* 1792 and gives some of the building's previous ownership history.

In 1891 the Salvation Army began purchasing land in neighbouring Hadleigh (outside the borough) for the establishment of a farming colony to transform the lives of London's poor and destitute by training them in farming practices and finding them agricultural jobs in Britain or the Colonies. As Leigh Park Farm stood close to the Hadleigh boundary it was purchased for use as a 'receiving station', where prospective farm colonists were assessed for their willingness to work and the genuineness of their intentions to be 'saved'. The Salvation Army purchased 67 acres of Leigh Park Farm in August 1893.

In 1906 the Salvation Army built an extension to the north of the farmhouse to give it a 'double-roofed' appearance. This extension (at left in the photograph) is so in-keeping with the original that it looks original itself, but a plan in the ERO

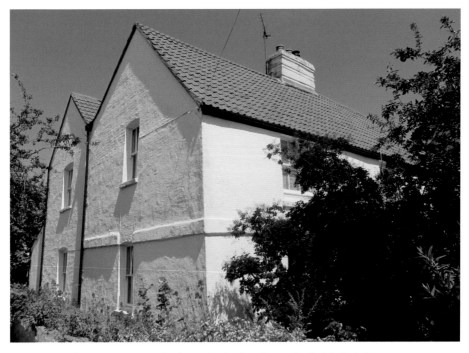

Nos 71–73 Olive Avenue in Leigh, formerly the farmhouse for Leigh Park Farm.

confirms that it is not. The extension included a kitchen, scullery, WC, bathroom and three bedrooms, and was a clear sign of the success of the Salvation Army's venture.

Agricultural depression in the late nineteenth century and the growth of Leigh after the arrival of the railway led to the sale of farmland across the parish for development with housing. The Salvation Army, which was beginning to scale back its operations, sold Leigh Park Farm to a local builder, Mr Walker, in 1923 and the farm's land was developed for housing between then and the mid-1930s as the 'Highlands Estate'. At the time of the sale the farm was described as being 'ripe for the immediate erection of good class residences, for which there is exceptional demand'. The farmhouse's conversion into two residences appears to have taken place before the sale, as it was described in the documentation as being let as two tenements. Each tenement had a parlour, kitchen, scullery and three bedrooms. The sale included stables, piggeries, cart sheds, a barn, a communal kitchen and a bath-house. The property was marketed as being provided with all services and close to bus routes and the planned Belfairs High School and Golf Course. The whole estate comprised 107.5 acres, including 2,000 feet of potentially profitable frontage to the busy London Road.

The estate's builder is commemorated in Walker Drive, which runs right next to the old farmhouse. Surviving trees from some of the farm's orchards can still be seen on the central reservations of Highlands and Sutherland Boulevards.

18. The Angel Inn, North Shoebury

Across town in North Shoebury stands another building with seventeenth-century origins, The Angel Inn.

Until the late twentieth century, when the parish was developed, the focal point of North Shoebury was a small group of buildings at the junction of what are now Bournes Green Chase, North Shoebury Road and Poynters Lane. Here were the village post office, shop and blacksmith's.

The post office-cum-shop (facing North Shoebury Road) and the blacksmith's (which adjoined it, but faced Poynters Lane) both closed *c.* 1977. They stood empty and derelict until the late 1980s when they were bought by local restoration expert, Malcolm Ginns, for conversion into The Angel. Phyl Stibbards, author of *Our Past has a Future: The Listed Buildings of the Shoebury Area*, was pictured with the derelict structures in the *Evening Echo* newspaper of 30 January 1989 and quoted as saying that 'the North Shoebury Post Office is under threat ... and if we have any really bad weather I think we could lose the roof'.

Malcolm has informed the author that The Angel comprises five separate buildings. The first, the blacksmith's (the taller section on the left of the first photo), dates from the early eighteenth century. The second, the left-hand end of the lower building, with the single dormer window, was part of the post office accommodation. This is the oldest part of The Angel, dating from *c.* 1650. The third separate unit was the right-hand end of the lower building, originally

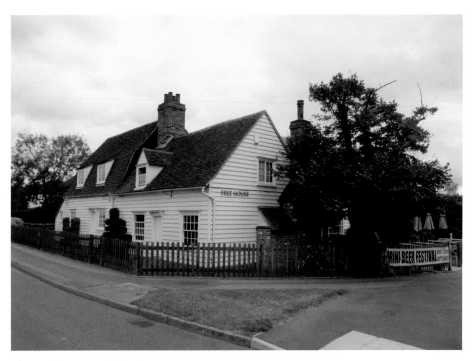

The Angel Inn, North Shoebury.

Angel Terrace.

a one-up/one-down cottage from the late eighteenth century. Although these last two buildings have been knocked into one, some exposed studwork has been retained inside to show the original demarcation between the two.

The fourth original building, which faced North Shoebury Road, was the post office and shop. This is also late eighteenth century. Malcolm found when restoring this section that the studwork of the building had been 'almost entirely eaten by snails' and that the whole structure was supported only by a thick coat of cement render.

The fifth part of The Angel – the thatched section facing North Shoebury Road – was built by Malcolm in the 1990s on the footprint of a thatched wheelwright's which collapsed in the 1920s.

Benton found that there was a house and orchard here in 1679, when they were sold, along with two acres of land, to Barking tanner William Hogg by Prittlewell shoemaker Benjamin Hawkins. It seems likely that this is the *c*. 1650 part of the pub.

In 1776 the properties here were bought by local man Christopher Parsons, whose family owned them until 1883. The road junction became known as 'Parsons' Corner' as a result.

In 1883 the buildings were sold to Mrs Elizabeth Mary Knapping, sister-in-law of Dale Knapping who owned South Shoebury Hall. They were sold again in 1887, at which time they included a brewhouse, stable, cart shed, 'pig's court' and gardens.

Lily Jerram-Burrows recorded in her 1981 history of North Shoebury that the shop sold 'everything from paraffin to postcards' and 'closed about four years ago'.

The Angel Inn opened for business in the early 1990s. The name of the pub was chosen because part of the site was known in the mid-nineteenth century as 'Angel Terrace'. This terrace, which stands to the south of the pub, was also purchased and restored by Malcolm.

Angel Terrace started life as a barn, with a cart entrance on the north-facing elevation. The main structure, according to Malcolm, is 'possibly late seventeenth century'. In the eighteenth century the building was converted into three cottages. By the late 1980s the front cottage was an antique shop; the other two were vacant and derelict. During the restoration Malcolm found the address '2 Angel Terrace' hidden under wallpaper on the chimney breast of the central cottage.

19. Thorpe Hall, Southchurch

In neighbouring mid-seventeenth-century Southchurch a new manor house was being built. Thorpe Hall is one of the minority of buildings in the town to carry a date – 1668. It has been the clubhouse of Thorpe Hall Golf Club since the latter's foundation in 1907, but the manor which became Thorpe Hall is mentioned as far back as 1086.

Southchurch Hall was the main manor in Southchurch parish. This was sub-divided *c.*1650 into two separate manors, Southchurch Hall and Southchurch

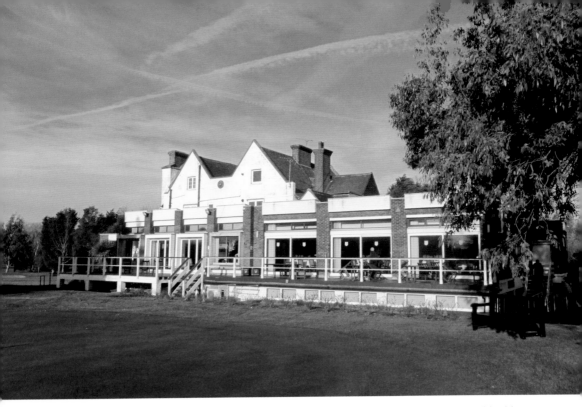

Thorpe Hall, Southchurch, now the clubhouse for Thorpe Hall Golf Club; the original building remains visible behind the modern extension.

Wick (the latter now demolished). Thorpe Hall was a secondary manor which appears conversely to be a union of two pre-existing smaller manors: South Thorpe (Thorpe Hall) and North Thorpe (now lost). These may well have been Danish settlements, since 'Thorpe' is a word of Danish origin. Alternatively, the derivation could be Old English: the word 'thorp' in that language means 'settlement'.

The golf club was set up by Col Ynyr Henry Burges, whose family had owned the land since 1791. The 1838 Tithe Award for Southchurch gives John Ynyr Burges as the owner, though the building was then in the occupation of Frederick Stallibrass.

Once Southchurch had been acquired by Southend in 1897, building development soon took place. By 1910 Thorpe Bay, in which the golf club stands, had been created as a completely new high-class seaside resort. The golf club was provided as a complementary attraction for the new community.

2c. Suttons, South Shoebury

Just over a decade later, another new manor house was built in neighbouring South Shoebury: Suttons, constructed in 1681. This manor's lands may have been carved out of those of South Shoebury Hall. It was the preferred home of the last Lord of the Manor, Dale Knapping, who owned both properties.

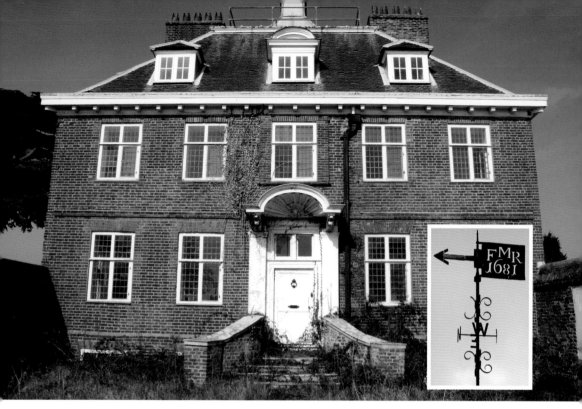

Suttons, South Shoebury.
The weathervane at Suttons (inset).

Also known as 'Manor House', Suttons replaced an earlier building which may have had a larger footprint. The date of the building appears on its weathervane, which also features the letters 'F', 'M' and 'R'. The same details are recorded over the main door.

The tenancy of Suttons was acquired in 1676 by Francis Maidstone, who was a 'shearman' and 'mercer' in London (a dealer in woollen textiles). It was probably Maidstone who demolished the previous house and built the current one, although an alternative theory is that the landowner, Daniel Finch, was responsible. The letters probably relate to Francis and his wife Rebecca, though as an SBC guidebook observes, 'this sort of emblematic tribute [from a landowner] would be unprecedented for the house of an estate tenant'. Benton notes that what was probably Maidstone's (or possibly Finch's) coat of arms, 'although greatly blundered', was once represented on oak panelling in the dining room. Maidstone was declared bankrupt in 1694 and the tenancy was taken over by Robert Bristow, whose descendants were also tenants of South Shoebury Hall.

Before Shoeburyness High Street was constructed, the main road to Suttons ran from west to east, along what are now Elm and Blackgate roads. It then turned north to Suttons and beyond that to Great Wakering. Suttons has close associations with Red House (1673), which stands at the junction of the above roads. Both buildings were tenanted by Maidstone in the 1670s and both display the 'F', 'M', 'R' letters. Jerram-Burrows found that in the nineteenth century the

gardener and bailiff for Suttons lived at Red House. The latter may have been the lodge for Suttons, with a gate outside it to control access to the mansion. This could be where the name 'Black gate' Road comes from.

Suttons was described in the 1860s as having a glass portico, oak staircase, oak-panelled hall and dining rooms, servants' quarters and at least nine bedrooms over its three above-ground floors/attics. It was later known as 'Kennets' and 'Kings', after occupants with those surnames.

In *c.* 1890 a number of local farms were acquired by the military for the construction of the New Ranges firing range; Suttons was one of those. Since then the road north has been closed to the public and replaced by the parallel Wakering Road (opened 1891). Suttons itself has become equally inaccessible. The stables, coach house and cart sheds of the building were used initially as gun sheds and stores. The main building housed the Range Master Gunner's office. The yard was used for railway sheds. In 1897 Suttons was described as having a large cellar which had been used as recently as the 1840s to hide smuggled alcohol.

During the Second World War the building was converted into offices. After the war, it was converted into flats for single officers. Jerram-Burrows wrote in 1978 that Suttons' original oak panelling and staircase were damaged after the war (not because of it) and consequently removed. This perhaps took place during the flats conversion process. The SBC guidebook states that 'until the 1970s the house was used as staff living quarters upstairs and office accommodation on the ground floor'.

21. Sutherland Lodge, Prittlewell

When the eighteenth century dawned, Prittlewell was past its peak. Nevertheless, some interesting buildings remain from this period, not least Sutherland Lodge, a white, weather-boarded house at No. 60 East Street.

SBC's Prittlewell Conservation Area Character Appraisal (PCACA, 2003 Draft) describes it as 'an eighteenth-century timber framed and weather-boarded cottage, typical of local vernacular buildings, in two ranges with a tiled roof to the front and slate roof to the rear'.

While this book was being written, the building's owner commissioned a full, detailed survey of it, and he and the survey's author, Ellen Leslie, have been kind enough to make the information available. Ellen has established that the front range of the building dates from at least 1717; it is depicted on a manorial map from that year. The back range was evidently added later. There is also a Victorian brick extension at the back of the house.

In 1841 Sutherland Lodge was occupied by Henry Sopwith. In 1905 it was sold by the executors of the estate of Joseph Skilton and was described as a 'brick- and timber-built dwelling house … with stabling and extensive garden'. It had four bedrooms on the first floor, two sitting rooms and a kitchen on the ground floor, and a cellar. The stables, which had a loft above them, were accessed by a separate

Sutherland Lodge, Prittlewell.

driveway. The whole was let to Lucy Wyeth. By the 1930s Sutherland Lodge was owned and occupied by Henry Thomas James Bush.

A few doors west of Sutherland Lodge, at No. 30 East Street, stands Prittlewell House. This also appears to date from the eighteenth century, but the PCACA notes that 'internally there is evidence of an earlier timber-framed building'. Nos 37–41 West Street are also eighteenth century.

22. The White House, North Shoebury

In eighteenth-century North Shoebury, agriculture continued to dominate. One of the surviving farms from this period is The White House, which stands to the west of Parsons' Corner.

Benton gives precise dating information about this building, writing that 'Edward Kennet built the present house, and died there in 1787 ... He died before it was quite finished'. Edward and his wife Priscilla were buried at South Shoebury Church.

Benton's reference to 'the present house' is made because there were evidently at least two earlier houses on the site; parts of the immediately preceding one survive. Benton traced the first house back to *c.* 1329–30 when it was owned by Peter Barber and known as 'Barber's', a name which survived for a time after Kennet constructed his replacement building. He also found that the property's owner in 1732 was Robert Kennet (presumably a relation), who 'built a cottage on the waste, which has his initials thereon and the date 1733'. Kennet's cottage, which presumably replaced the *c.* 1329–30 building, has gone, but The White

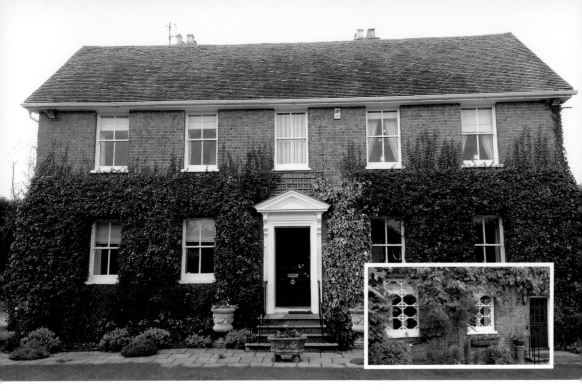

The White House, showing the east front.
The re-sited ornamental windows at The White House (inset).

House's present owner has made evidence available to the author which states that 'there are still parts of the cottage remaining'. These parts have been dated to 1728. Barber's is shown as being in the occupation of Edward 'Kennit' on a famous map of Essex produced by John Chapman and Peter André in 1777.

In 1791 The White House was 'in possession of' Thomas Parsons of South Shoebury Hall (d. 1808). Around 1810 it was sold by his children and its lands partitioned. In 1816 the 'mansion and farm' of 'Great Barber's' in 'North Shoebury and Southchurch' were sold. It is presumed that this is the same building and that it had lands which straddled the parish boundary.

In the late 1880s The White House was owned by James Tabor, by which time it had also changed its appearance. 'It was formerly in plaster work,' wrote Benton, 'with windows of curious ornamental construction, but is now brick-fronted and modernised.' The current owner advises that the ornamental windows, which appear to have been re-sited, date from the 1600s. It was presumably the plaster work which led to the building being called the 'White' House.

Williams found that in 1919 the building – and 42 acres of land which were then being operated as a market garden – was sold to Southend Estates Company for development. Development was evidently delayed, however, as it was not until 1981–88 that the house's land was built on and transformed into the northern part of the Bishopsteignton Estate.

The farmhouse for New Farm in nearby North Shoebury Road is contemporary with The White House, dating from c. 1781.

23. Southchurch Lawn, Southchurch

Not far from The White House, in neighbouring Southchurch, stands Southchurch Lawn. This also appears to date largely from the eighteenth century, though the current owner has informed the author that part of the north side may date back to the sixteenth. The visible façade all looks classic eighteenth century, so any sixteenth-century parts have presumably been subsumed into later work.

The earliest date given in documentary sources is 1730, when, according to William Pollitt in his book *Southchurch and its Past*, 'The Lawn – then known as Bakers and Munns – was in the possession of John Lancely'. He adds that 'about the middle of the eighteenth century the Lawn was known locally as China Hall, from a lady who lived there having compared herself to china and the common people of the district to earthenware'. It appears as that on Chapman & André's map (1777). The south, neo-classical side appears to be late eighteenth century.

In the early nineteenth century, with nearby Southend attracting increasing numbers of wealthy visitors (see later), the building was a focal point for the local social set. This is a little surprising given its inland position, but it was clearly a house of some status. In 1801 the building's occupant, Thomas Sumner (a relative of John Sumner, a future Archbishop of Canterbury), hosted a visit of the five-year-old Princess Charlotte, daughter of the Prince of Wales, later George IV.

Southchurch Lawn from the north-west.

There is a tradition that Admiral Horatio Nelson and his mistress, Lady Emma Hamilton, were amongst the visitors to Southchurch Lawn around this time. Kate Williams, author of *England's Mistress*, a biography of Lady Hamilton, found that in 1805 'Emma, desperate for a respite from the demands of her creditors, travelled to Southend'. Williams adds that 'newspapers ... reported that Emma was holidaying with Charlotte Nelson [niece of Horatio] ... and ... Horatia [the couple's daughter]...' but not, apparently, the Admiral.

Like North Shoebury, Southchurch was home to the Parsons family of farmers. Christopher Parsons, the naturalist (1807–82), was born at Southchurch Lawn and later lived at North Shoebury Hall before returning to his birthplace for the last six months of his life. He studied botany, ornithology, meteorology and entomology, as well as running a farm. Parsons kept diaries of his life in the locality for over fifty years and a daily meteorological record for more than twenty. He also discovered the 'Essex Emerald' moth. He was twice married, the second time to Mary Benton, sister of Philip.

In 1814 Southchurch Lawn was owned by the Revd J. Sumner. This is presumably the John Sumner who later became archbishop; he was a master at Eton College at the time. The building was referred to as 'The Lawn, alias Loveneys, alias Baker's & Munn's'.

In 1903 the property had eight bed and dressing rooms on the first floor and three servants' bedrooms on the second. The ground floor had a 'handsome billiard room', while outside there was a lake, boathouse, farmyard, kitchen garden, two walled gardens, stabling for five horses and numerous acres of 'park-like meadow land'. The property possessed views of the Thames Estuary and Kent.

Throughout much of the twentieth century Southchurch Lawn was home to Eton House School. This led to it having some modern extensions erected to the east.

Lawn Cottage across the road also dates from the eighteenth century and appears to be depicted on Chapman & André's map. However, a Hambro Countrywide sale catalogue (1997) uniquely describes it as 'a Grade II-listed sixteenth-century cottage'. Believed eighteenth century, with possible sixteenth century origins, it has a similar provenance to the main building.

Southchurch Lawn, Lawn Cottage and The Rose Inn (*c.* 1800 and technically in Southchurch despite often being referred to as being in Great Wakering) together formed the basis of a hamlet which retains a unique character to this day.

24. Parsons' Barn, North Shoebury

In neighbouring North Shoebury another eighteenth-century building survives, albeit performing a new role. The Parsons' Barn public house started life as a barn at the now-lost North Shoebury Hall. During the nineteenth century this was in the tenancy of the Parsons family – hence the name.

The barn appears to have been built in 1763 by Christopher Parsons for a cost of £57. The contract for this included £1 to take down a fifteenth-century barn which stood on the site and reuse whatever timbers could be salvaged from it.

Parsons' Barn: formerly a barn on North Shoebury Hall farm, now a public house.

It is impossible to tell from the available documentary evidence whether any of the earlier building survives in situ in the current one. The current building's appearance bears favourable comparison with earlier barns; perhaps it was built and/or restored in imitation of the one it replaced? Or perhaps some of the original timbers have been reused, but not necessarily in their original positions?

The reported history of the barn is certainly confused. The BLB describes it as 'a late C16 timber-framed and weatherboarded barn of 6 bays with a gabled entrance bay on the west side and an outshot on the south side of the entrance bay'. However, an article in the *Evening Echo* on 7 June 1983, when North Shoebury was being developed and the barn was being converted for public house usage, described it as 'up to 300 years old', i.e. *c.* 1683. The newspaper further reported that a new building was being added at the rear to provide living accommodation and services. By August 1985, however, by which time the conversion had been completed, the *Echo* was dating the barn to 1763 and noting that it stood on the site of a fifteenth-century one. The newspaper added that 'most of the original timbers remain in the renovated barn'.

It seems likely that the date of 1763 came to light while the building's history was being researched during its conversion into a pub and that the BLB's listing entry, made in 1977, has not been updated.

North Shoebury Hall burnt down in 1968 and its other outbuildings were demolished in 1980. The new use found for the barn and the comparative late development of North Shoebury both resulted in the building being saved.

25. The Hope Hotel, Prittlewell (South End)

Only now, in the eighteenth century, does Southend come into its own, with the establishment of a hamlet of oyster fishermen's cottages on the shore at the 'South End' of the manor of Priors Hall (Prittlewell Priory) in Prittlewell. The honour of oldest surviving building from that hamlet appears to belong to The Hope Hotel.

The Hope is not shown on Chapman & André's map (1777), but the map does show its site looking next in line for development as the fledgling settlement of 'South End' extends westwards from what is now Southchurch Avenue. The BLB describes it as 'a stuccoed building with a parapet of *circa* 1780', but this date is at least 10 years earlier than that given in other sources.

The most definitive dating statement comes from Stephen Pewsey's *The Book of Southend-on-Sea*: 'first built as Capon's Coffee House and Hotel in 1791, it became the Hope in 1798'. Jessie K. Payne (*Southend-on-Sea: A Pictorial History*) adds that 'there used to be a stone in Prittlewell churchyard to John Capon of the Hope Inn, Southend, who died on 10 October 1797'. The *Chelmsford Chronicle* newspaper of 6 July 1798 advertised a sale of boats 'at the sign of the Hope, Old Southend, Essex'.

The Hope changed significantly in appearance in 1877 when it was massively extended to the west to accommodate the town's growing tourist trade. The building was owned at the time by Henry Luker & Co., a significant local brewery company.

The Hope Hotel, the oldest surviving building in 'South End'.

The Hope Hotel, showing the original 18th-century building (with balcony) and the massive 1877 extension to the left; the small right-hand extension post-dates 1877.

Plans of the extension, drawn up by architect Thomas Goodman and now held in the ERO, show that its ground floor was to be used as a smoke room and public bar. The first floor was earmarked as a large assembly room, while the second floor was planned to accommodate four additional bedrooms. There was also a cellar. A gated alleyway to the left of the building (now occupied by Doodah's Takeaway) led to a yard behind the hotel. The layout inside the building preserves the distinction between old and new parts.

26. The Royal Hotel & Terrace, Prittlewell (South End)

As early as 1768 there were plans to establish South End as a sea-bathing resort for the wealthy. There was, however, hardly anywhere for visitors to stay and not much for them to do.

Before 1790 there were only around two dozen houses in South End, which was home to just 125 people. There was, however, a profitable river trade with London and a summer coach service to the capital. All this activity was taking place on the flat seafront, but those behind the resort proposals had the clifftop above and to the west of the village in mind as the site for their new development. They knew that grand, prominently sited buildings would attract the attentions of travellers on the Thames.

The site they had in mind was owned at this time by the Lord of the Manor of Milton Hall, Daniel Scratton. (Milton Hall's site is now occupied by Nazareth House.) In 1790 Scratton sold this land to a company called Pratt, Watts & Lowdoun for the development of a hotel and terrace, with coach houses behind. These were duly built in 1791–93, initially as the Grand or Capitol Hotel and Terrace, now The Royal Hotel and Terrace. The coach houses behind – now Royal Mews – were designed to provide space for carriages and horses and

The Royal Hotel, with Royal Terrace to the left.

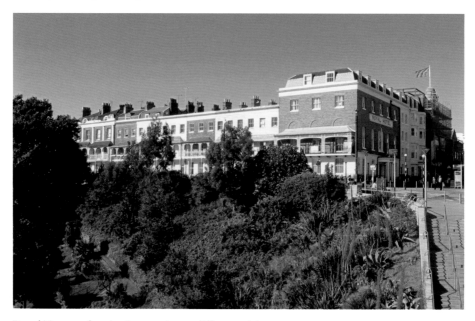

Royal Terrace, showing its prominent clifftop position.

accommodation for the groom. The scheme included the construction of a road to link the new resort to the original village (now Pier Hill) and another to the north leading to the London Road (the High Street). To distinguish the clifftop resort from the old fishing village, the term 'New South End' came into being, with the original village becoming 'Old South End'.

The hotel opened with a grand ball in July 1793. It brought with it a number of new attractions: card games, a billiard room, bathing machines, dancing, a theatre and pleasant clifftop walks. There was also a library on the opposite corner of the High Street (where The Royals is now) which hosted raffles and stocked London and provincial newspapers.

The new resort began to attract a high class of visitor and was very fashionable with London gentry. The original fishing village also benefitted, through both extra trade and a growing resident population. The two communities would soon merge into one.

The change of name from 'Grand' to 'Royal' was occasioned by the visit of Caroline, Princess of Wales, in 1803 and/or 1804. She stayed for three months in three houses in the terrace. The kudos arising from this visit helped establish 'Southend', as it soon became known, as one of the key bathing places in the country. Lady Emma Hamilton, mistress of Admiral Horatio Nelson, stayed in Royal Terrace in 1805 and hosted a ball in his honour.

In the late 1960s and early 1970s the Royal Hotel and Terrace came under serious threat of demolition; much of the building was in need of repair and the town was going through an intense period of modernisation. Thankfully, many local people recognised the importance of the building to the town's history and set up a campaign to save it.

The Royal Hotel is arguably the most important building in the whole of the borough, as its construction marked the start of the deliberate transformation of the old fishing village at the 'South End' of Priors Hall Manor in Prittlewell into the sprawling modern town that exists today. Without it, 'South End' may have remained a fishing hamlet.

27. The Minerva Hotel, Prittlewell (South End)

While the beginnings of the modern town were being set in motion by the construction of The Royal Hotel, development gaps in the fishing hamlet were still being filled. One of the most prominent arrivals was 'The Great House', built on the corner of the road into the hamlet from Prittlewell (now Southchurch Avenue). The Great House was built by wealthy local barge owner, Abraham Vandervoord, *c.* 1792/93. It is now the Bourgee restaurant, but is better known as The Minerva Hotel.

The Great House was originally a grand residence for Vandervoord's family, but it was converted into a hotel and public house in the nineteenth century to meet the

Abraham Vandervoord's 'Great House', later the Minerva Hotel, currently the Bourgee Restaurant.

needs of the growing tourist trade. The early days of the building are comparatively well documented, thanks to the sale particulars from an 1829 auction:

> The ground on which the messuage [The Minerva] and buildings [five other lots in the auction]... are erected, was granted by the Lord of the Manor of Prittlewell Priory to the late Abraham Vandervoord, at a court held for the said manor, on 16th of Jan., 1792.

Although Vandervoord held the land in 1792, it was not until 1793 – according to Benton, at least – that he erected the building.

The building appears in a fabulous painting by C. C. Coventry from 1807 (held at the Beecroft Art Gallery), but without the right-hand end in the first photograph; the frontage to what is now Eastern Esplanade is a later addition. This can actually be deduced from the plan of the building.

The 1829 sale particulars describe The Great House as 'Lot 1', Vandervoord's 'mansion house', with two cellars underground, three parlours, a kitchen and a pantry on the ground floor, six bedrooms on the first floor and two more bedrooms in the attic. Its outbuildings included a counting house, warehouse, granary, dairy, hop house, knife house, scullery and brewhouse. It also had a yard, stable and chaise house, and a garden fenced with iron palisades. The building's owner was responsible for maintaining the sea defences for the length of its plot. The mansion was occupied at the time by James Vandervoord and James Pearce, although it was bought by a Mr Gregory.

'Lot 2' in the auction was 'a brick-built cottage in Old Southend called "Minerva House"'. This two-bedroomed property was then occupied by Mrs Poole, but it

The nineteenth-century south frontage; the dome of the Kursaal (see later) looms behind it.

was bought by James Vandervoord, who also purchased a timber-built and tiled granary nearby. Abraham Vandervoord had a barge named *Minerva* which was in his ownership as early as 1810. As his residence was originally called The Great House, it appears that its later name, The Minerva, was adopted for the hotel/pub from either the cottage or the barge.

The building was still residential in 1841, but by 1870 it was owned by Luker's Brewery. It may have been Luker's who added the extension.

The Minerva closed around 2010. It briefly became an Indian restaurant called 'Tiffin's', before closing and reopening as the Bourgee in 2014.

28. The Britannia Hotel, Prittlewell (South End)

The nearby Britannia Hotel also began life as a residence. It is shown as such in Coventry's painting. It was still residential as late as 1841. According to Pewsey, who described it as being 'built nearly two centuries ago' in 1993, it must have been built in or shortly after 1793.

Sometime after 1841, as Southend's tourist trade grew, the Britannia was converted into a public house and hotel. By 1895, when it was offered for sale due to the death of its owner, Mrs Ellen Bateman, it was described as 'the valuable old-established, full-licenced tavern'. The maximum 'old-established' can mean is fifty-four years. It had, however, certainly been converted into an inn by 1854; an 'abstract of title' dating from that year is mentioned in the sale particulars.

The sale included a plot of land in front of the pub, and five cottages and a stable yard at the rear. The pub had six bedrooms and two WCs on the first floor (which

The Britannia Hotel.

was accessed by two separate stairways) and bars, kitchen, a coal house and a private parlour on the ground floor. There was also a beer cellar. The property was then copyhold of the manor of Prittlewell Priory, on whose land it stood. The whole site had been let to William John Penny for twenty-one years from 1885.

At the time of writing the Britannia was closed due to flooding and put up for sale.

29. Bow Window House, Prittlewell (South End)

Another building on a prominent site in Old Southend was 'Bow Window House', a grand residence at the foot of what is now Pier Hill. This building is still there but is almost unrecognisable, as the ground floor is now occupied by Sunspot Amusements.

An agreement was made on 9 December 1791 to transfer the main part of the plot here from Edward Scratton (whose family were Lords of the Manor of Milton) to John Sanderson. This agreement refers to brick residences, a coach house and some stables which were 'then erecting or to be erected'. By July 1795 it was owned by Abbott Kent and described as a place 'whereon a messuage dwelling house and premises were intended to be erected'. In 1796, however, it was recorded that Kent 'surrendered the above premises to the use of his will'. This suggests that the building was constructed *c.* 1795–96. Deeds from March 1802 refer to 'a bricked messuage or dwelling house belonging to the said Abbott Kent', so it was definitely there then.

In January 1810 the property was put up for auction. It was described as 'eminently advantageous in point of situation' as 'South End' was then 'a watering

Bow Window House, which stands at the foot of Pier Hill.

Bow Window House (the two right-hand bays), with the later addition (three bays, set at a different angle, distinguishable by their higher roof) to the left.

place [which was] becoming more and more attractive and fashionable'. The property appears to have been bought by Peter Denys, because when Denys died in 1816 he left it to his wife, Lady Charlotte Denys (née Fermor). Benton reports that Lady Charlotte was a regular visitor to the town 1818–26.

In the late 1820s Lady Charlotte conveyed a portion of Pier Hill to the Southend Pier Company. This conveyance reveals that Bow Window House then comprised just two bays and therefore that the building to the immediate west of it, which looks contemporary (see second photograph), was actually added later. The difference in construction can be seen from its angle to the road and the treatment of its roof line. This later addition, added sometime between 1846 and 1868, is very much in keeping with the original building.

During the early nineteenth century Bow Window House housed the 'Marine Library'. It is shown as this on an excellent early drawing of Southend known as 'Duheit's Panorama' (*c.* 1815–25) and in other contemporary paintings.

In 1836 the building was bought by John Copland, at which time it was described as both the 'late Marine Library' and the property of the 'late Peter Denys'. Copland's letters to his tenant in 1836–39 refer interchangeably to it as 'the Marine Library', the 'late Charlotte Dennis's [sic] property', 'Bow Window House', 'Bow Windowed House' and 'Bowed Window House'.

In 1846 the building was marketed as 'particularly eligible for the residence of a family of respectability, or for investment'. The ground floor featured two front dining rooms and two back parlours with closets. On the first floor there were two drawing rooms, 'a small boudoir' and two 'airy' bedrooms. The second floor housed four more airy bedrooms with 'convenient closets' and a dressing room. There was also a basement, with a housekeeper's room, closets and three kitchens. The sale included a garden, coalhouse and a number of outbuildings. The property was bought by a Mr Nixon; perhaps it was he who enlarged the building?

This early piece of Southend's history is now largely forgotten, but it is an important survivor from the late eighteenth-century town.

30. Fishermen's Cottages, Prittlewell (South End)

The original eighteenth-century oyster fishermen's cottages have gone, but some fishermen's cottages from early in the following century survive.

Nos 40–43 Eastern Esplanade are described by the BLB as 'early or mid C19'. They cannot predate 1815, as they do not appear on Duheit's Panorama, the earliest date for which is given as that year. They may post-date 1840. The BLB observes that 'the arrangement of the facade of these fishermen's cottages reflects their specialist function' and that 'the exterior remains substantially intact and reflects the regional vernacular building tradition'.

The buildings are indeed typical of the period, being timber-framed and weatherboarded, with slate roofs. The first two are H-shaped in plan, with wing extensions to the rear (note the different rooflines and frontages).

Former fishermen's cottages at Nos 40–43 Eastern Esplanade, Southend.

Nos 44–45 Eastern Esplanade date from the same period and had the same original function, but are constructed of brick. Later brick buildings to the east (No. 46 onwards) have been added to the row, and have been tastefully built in the same design.

Madigan's Café at No. 26 Eastern Esplanade may also have originated as a fisherman's cottage. The BLB notes that 'the fishing industry in the area has since declined and is virtually non-existent today'. This area is now largely touristy, becoming more residential as one progresses further east.

Across town in Leigh another former fishermen's cottage survives at No. 28 Leigh Hill. The *Evening Echo* of 8 April 2015 carried an article about this building which included an interview with its owner. It was described as being '200 years old' and 'built out of timber from old boats in the 1800s'. The BLB describes it as 'weatherboard over timber frame, set on [a] brick plinth ... 2 storeys over basement, set into slope of hill'. It also states that it once incorporated commercial premises: the windows on the first floor on the north side are believed to have replaced original loading doors, with a stable/loosebox on the ground floor and a workshop over. It adds that the cottage features early-nineteenth-century sash windows and is 'an unusual survival of a type of building which was once common in the fishing/ship building communities along the riverside'.

31. The Old Custom House, Leigh

Although Leigh's fishing industry was thriving at this period, the community's importance as a port had been declining since the eighteenth century, when the silting up of its deep water channel and a national increase in the size of shipping

combined to reduce the amount of import/export trade passing through the village. This trade had been practised over many centuries, with Strand Wharf being the centre of activity, especially for imports. The Lord of the Manor of Leigh owned Strand Wharf and it was consequently available for public use, unlike some of the other wharves in the parish. Judith Williams found that Strand Wharf existed as far back as 1255.

With Leigh being a port, shipbuilding centre and major trading town, it was not long before a customs officer was appointed to assess incoming goods for the correct duty and root out smuggled ones. It was a requirement in Leigh for customs officers to be from outside the parish and not to marry into local families, in an attempt to prevent collusion. Some of Leigh's nineteenth-century officers came from Scotland and Ireland.

The earliest documented Custom House in Leigh was established in 1738 at, unsurprisingly, the head of Strand Wharf. There had been a customs officer in the town since at least 1732 but the premises had been inadequate. Joyce MacConnell, who researched the history of Leigh's customs office in the 1970s, found that the 1738 premises were constructed as a partial rebuilding of an existing house, possibly 'the mansion house of the Hare family'. In 1808 the Crown purchased this part of the building from the owners. An inventory of the customs officer's possessions in 1735, unearthed by Miss MacConnell, includes iron weights, a beam and scales, a wooden chest bound with iron, blunderbusses, pistols, cutlasses and a sword.

In 1815 the 1738 building was demolished and a new one erected by Thomas Hill on the same site. Some of the previous building's materials were reused in its construction. The 1815 building is still there, though now a private residence.

The Old Custom House, Leigh.

The Leigh Conservation Area Appraisal (LCAA) describes it as being built from 'the palette of local materials': slate roof, stock brick and sash windows.

In 1856, when the railway was being laid through Leigh, the railway company took over the building and the customs officers moved to a now-lost replacement building east of Bell Wharf which they shared with the coastguard.

There are numerous reports of smuggling being rife in Leigh in the eighteenth and nineteenth centuries, with goods being landed by boat and taken to nearby Dawes Heath under cover of darkness. This is borne out by advertisements in the *Chelmsford Chronicle*, with sales of seized illicit goods such as brandy, rum, sword blades, gun flints, coffee, china and textiles being regularly announced at the Custom House. In 1892, when the Peter Boat pub burnt down, a secret room was discovered beneath it, accessible only from the river. This is presumed to have been used by smugglers.

In 1881, by which time Leigh's importance as a port was in terminal decline, the customs officers were withdrawn from the town. The shared coastguard building was demolished some twenty years later.

In the 1970s and early 1980s The Old Custom House housed a craft shop and workshop. It was sold by British Rail in November 1985.

32. Kents Moat House, North Shoebury

Like Leigh, the other parishes continued for the time being to evolve independently of Southend.

In North Shoebury the Kents Moat House manor house was rebuilt in 1824 by Samuel Benton, father of Philip. This and North Shoebury Hall were the two original manors in North Shoebury parish, both dating back to at least 1086. The Kents Moat House manor was owned at that time by Odo, Bishop of Bayeux, Earl of Kent and half-brother of William the Conqueror.

The building still has the remains of a moat around it. There used to be a gatehouse over this, which may have contained a drawbridge; this suggests that the original manor house was erected with defence in mind. The 'Kents' part of the name comes from a previous owner, possibly the Earl but more likely either a fourteenth-century owner, Richard Kent, or a fifteenth-century owner, John Kente.

From 1501 to at least 1631 the property was owned by Henry Baker and his descendants. In 1686 it was occupied by John Witham and comprised the house, the moat, some barns, an orchard and 160 acres of farmland. Witham sold it in 1692 to Anthony Bond from Wapping and by 1716 the property was owned by Bond's son, James, a Stepney brewer. Some of the land was leased to Robert Kennet, sometime owner of neighbouring White House Farm. In 1720, after James had died, his sisters sold it to George Asser from Southchurch.

By 1824 Kents Moat House was in Samuel Benton's occupation. Philip, his son, writes the following: 'The present house was built by Samuel Benton, snr., of [North] Shoebury House, during his occupation, *circa* 1824. The old mansion was a long, large and ancient building with a double roof. It stood nearer the water than the

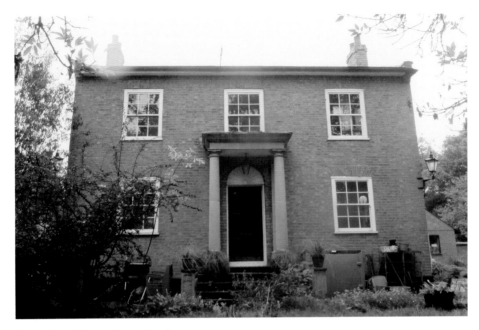

Kents Moat House, North Shoebury.

present one.' Samuel also filled in the southern section of the moat and the southern part of the western section. The Tithe Map of North Shoebury (1849) shows Samuel as occupier, but George Asser White Welch as owner. It is possible that a part of the current house known as the 'bakery' is a survivor from the previous building.

In 1920 Kents Moat House was sold by Margaret and Edith Knapping to the Southend-on-Sea Estates Co. Ltd, but the land's planned development for housing did not take place until the 1980s. Maureen Orford records that in the 1930s the building was occupied by a Mr Cooper, who owned an enormous scrapyard on the other side of the nearby railway bridge.

In the 1970s an unrealised plan to build an airport on Maplin Sands specified the construction of a railway to the south of Kents Moat House across North Shoebury Road and on through the site opposite, where Asda is now. By *c.* 1980 when its land was being developed (along with that of White House Farm and New Farm, to form the Bishopsteignton and Aylesbeare Estates), Kents Moat House itself was sold to Mr and Mrs Lister. Sue Lister was a well-known physiotherapist and the couple built an extension onto the north-west side of the building in 1981 to accommodate a physiotherapy clinic.

33. Chalkwell Hall, Prittlewell

Even in Prittlewell itself, the rest of the parish was carrying on as normal despite the growth of Southend within its boundaries. Here too, another old manor house was being rebuilt.

The manor of Chalkwell Hall dates back to at least 1381. The name may come from a well on the estate which was once lined with chalk or from the liberal application of chalk to the fields for agricultural purposes. The current building is the third to bear the name, each standing on a different site.

Benton surmised that the original, probably fortified, manor house was located on the site of a now-lost field called 'Moat Field', which lay to the south-west of the present house, nearer to the railway. In the 1880s the remains of this moat, which was 'of great depth and width ... enclosing more than an acre', could still be seen there. Benton found foundations, tiles and other debris within this enclosure.

The second Chalkwell Hall stood to the north of this, on the south side of the road to Leigh (now the westernmost part of Kings Road). It is shown in this position on Chapman & André's map of 1777. Again, in the 1880s, its site was still visible. Benton found that it was built of lath and plaster in the time of Henry VIII, with a frontage stretching down to the River Thames. The building was demolished in 1832 and the materials sold to Stephen Allen. A hoard of gold coins was found hidden under the staircase.

The present building was erected in 1830 by George Pendrill Mason, Lord of the Manor of Chalkwell, who set about buying up certain portions of the manors of Milton (to which it was subordinate) and Prittlewell Priory which had traditionally formed part of the estate, to combine them into one landholding. The Prittlewell Tithe Map (1841) shows Mason as owner and Stephen Allen as occupier. Mason

Chalkwell Hall, widely thought of as being in Leigh, but historically in Prittlewell parish.

bought the manor from the prosperous Tyrell family, who owned it in the eighteenth and early nineteenth centuries. Some of the family rose to high ranks in the nobility and they owned much other land and property in Essex and Suffolk.

When George Mason died in 1880, Chalkwell Hall passed to his niece, Catherine Courmouls Bear. She died in 1883 and left it to her husband, Thomas. He died in 1895, and in 1899 the whole estate was put up for sale.

The hall was described then as a 'comfortable, old-fashioned manor house'. It had three bedrooms on the second floor, two large ones on the first and a dining room and drawing room on the ground. It also had a basement, with kitchen, scullery and 'servants' hall'. There were stables, piggeries, a cattle yard, kitchen and fruit gardens, a brewhouse and a dairy, and 262 acres of land which were 'ripe for immediate development into a bracing and charming seaside resort' which could become 'a select and much desired residential suburb of the favourite seaside town of Southend'.

In 1901 the local authority purchased the hall and its immediate grounds for use as a public park. The select suburb of Chalkwell was indeed created around it out of the hall's lands.

Chalkwell Hall is currently occupied by the arts group, Metal Culture, who run the popular Village Green music and arts festival. In 2015 Metal created what they claim is the world's first digital art park, with trigger points on trees in Chalkwell Park allowing smartphone and tablet users to download art from around the world.

34. Leigh Library, Leigh

Back in Leigh, the construction of a replacement building was changing the layout of the town.

Leigh Rectory, now Leigh Library, was built in 1838 by Reverend Robert Eden (incumbent 1837–51), who was new to the parish and keen to make his mark. Eden demolished the previous rectory and closed up a number of historic, well-used public lanes. One of these, Church Hill Lane, led directly up from the fishing village next to the Ship inn. Another, Chess Lane, passed east-to-west to the south of the rectory along the top of the hill. He replaced the former with a new, steeper, hillside path to the east – the present Church Hill – and the latter with a new east-west road to the north – Rectory Grove (Broadway West came later). Three other paths up to Chess Lane from the fishing village were also stopped up. These actions increased the amount of land around the rectory; land which was duly enclosed and made private.

Benton wrote disparagingly of Eden's actions, noting that Leigh people had lost, in Chess Lane, a direct and pleasurable route with good views and had been given in return 'a right of way at the back of the rectory, partly bounded on the south by an ugly wall, shutting out the entire view'. Church Hill Lane had been an important route from the fishing village to the church for weddings and funerals.

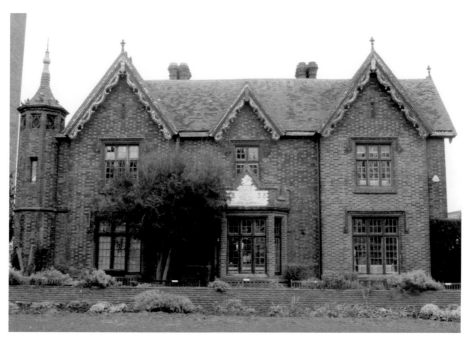

Revd Eden's 1838 rectory from the south.

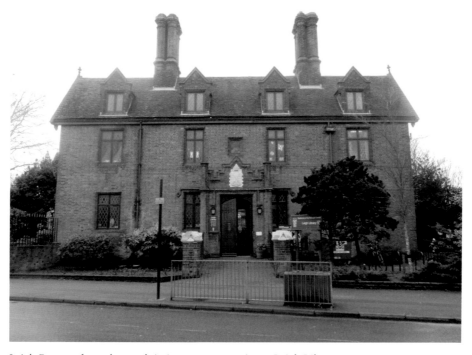

Leigh Rectory from the north in its post-1928 guise as Leigh Library.

Its replacement, Church Hill, was too steep for most funeral processions, so they had to go via a longer route up what is now Leigh Hill. Eden, who was a wealthy man, nevertheless contributed much to the growing Leigh village, restoring the church, building a school and helping cholera sufferers first-hand during an outbreak in 1849. He was also instrumental, as Benton puts it, 'in rescuing a place once notorious for the drunkenness and coarseness of its fishermen from the degradation to which it had fallen'. He went on to become Bishop of Moray & Ross and Primus of the Scottish Episcopal Church.

The conversion of Eden's building into a public library in 1928 necessitated some changes. A courtyard and outbuildings on the north side were demolished and a porch on the east side was moved to the north side to face a new road, Broadway West. This was constructed partly on the rectory's lands and partly on those of neighbouring Leigh House (then demolished) to the east. The parts of the gardens of both properties which survive were merged into one to form the Library Gardens, opened in 1930. A number of internal changes were made during the building's conversion into a library, 'a use,' according to the LCAA, 'which has done the interior no favours'.

By the 1830s general development was advancing up Leigh Hill from the fishing village to the clifftop. The Old Bank House on Leigh Hill dates from the second half of the eighteenth century, probably *c.* 1750s. Prospect House and Herschell House, further up Leigh Hill, are both probably *c.* 1820.

35. St John the Baptist, Southend

By the 1830s Southend was growing in size and stature, and the first steps were being taken towards unifying it with the mother village of Prittlewell. The trigger for this was a religious one: the growing churchgoing population living in the evolving town still had to go to St Mary's to worship, so a campaign was begun for the establishment of a church in Southend itself.

The site chosen was on the hill between the old fishing village and the new resort, which were gradually gaining a collective identity. The campaign reached fruition in 1842 with the opening of the church of St John the Baptist by the Bishop of London. Southend was formally granted separate ecclesiastical parish status from Prittlewell at the same time, the first administrative break of any kind between the mother village and the fledgling town and the first new parish since the Saxon period to be created in the area now covered by Southend Borough.

The original building is now largely hidden inside an expanded exterior because the population of Southend grew so quickly over the next twenty-five years that St John's soon needed extending. In 1869 new north and south aisles were added, and in 1873, a new chancel.

St John's churchyard is the final resting place of many individuals who played a significant role in the establishment of Southend. They include Thomas Dowsett, first mayor of the town council (1892–93) and founder of the

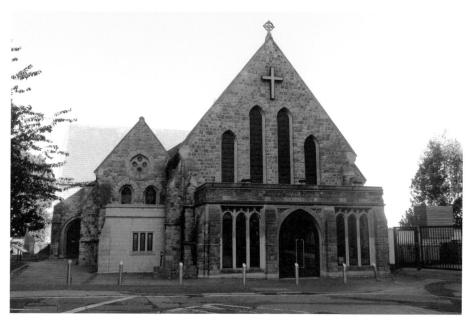

St John the Baptist, the original parish church for Southend.

Southend-on-Sea Estates Co. Ltd, and many councillors and aldermen who were involved in developing the town. Also buried there are (George) Warwick Deeping, a prolific twentieth-century novelist, and Robert Buchanan, a noted poet.

In 1906 further enlargement took place, with the nave being extended westwards and its roof raised. Box pews were replaced in the nave and transepts, and electricity was installed. In 1912, to commemorate the building's 70th anniversary, further enlargements were made, with extensions to the north and south transepts, and the chancel, the addition of a chapel, vestries and a new lobby area at the west end of the nave, and the provision of additional seating.

St John's occupies a now unassuming position, hidden away behind The Royals Shopping Centre (1988) and the Palace Hotel (1904), but it is nevertheless a very significant building in the history of the town.

36. Shoebury Garrison, South Shoebury

Southend was not the only place attracting visitors. In 1849 the military set up an establishment in South Shoebury. 'Shoebury Garrison', as this became known, was created on the marshes to the east of South Shoebury Hall, initially using an existing coastguard station as a base. From small beginnings it grew significantly. According to Major Tony Hill, who wrote an excellent book about the garrison, *Guns & Gunners at Shoeburyness*, 'the Crimean War [in the 1850s] was largely responsible for securing the future of Shoeburyness as a permanent station'. It duly became, in 1859, the home of the School of Gunnery (the first proper

artillery school in the country) and, from the 1860s/1870s until the late twentieth century, a key centre for weapons and armour experiments.

The garrison transformed South Shoebury, triggering rapid growth and the creation of a new village centre away from the historic settlement around St Andrew's Church. It also led to the improvement of the local road network and the establishment of gas and water supplies in the parish. The regular use by the military in postal correspondence of the term 'Shoebury Ness' (the coastal headland on which they had set up) led to the new community becoming known as 'Shoeburyness' and the term 'South Shoebury' dropping out of use. 'Shoeburyness' is now used as a catch-all term, covering the old North Shoebury parish as well.

Of course the garrison and its associated firing ranges ('the Old Ranges') comprised more than one building. The only buildings on the site in 1849 were the coastguard station and Rampart Farm. A small part of the former (c. 1825) survives as part of the old Officers' Mess; the latter was demolished c. 1871. The oldest surviving military building is a powder magazine, dating from 1851.

The most iconic buildings are the Horseshoe Barracks and Clock Tower, built in 1860. The footprint of buildings established during the 1860s/1870s remained largely unchanged until the early twenty-first century.

In 1889 the military began to purchase land to the north of the new Shoeburyness village: this would become known as 'the New Ranges'. Suttons (see earlier) was purchased at this time.

The 1851 powder magazine at Shoebury Garrison, the oldest surviving military building on the site.

The Clock Tower and Horseshoe Barracks at Shoebury Garrison.

When local government was reorganised in the 1890s, the old South Shoebury parish acquired Urban District Council status. The presence of the military was instrumental in this. Rural North Shoebury, by contrast, became simply a parish council, managed by the new Rochford Rural District Council.

The garrison and the ranges provided valiant service during the First and Second World Wars. After the latter, however, with odd peaks for the Cold War and the Korean War, their importance declined. In the late 1970s some of the land at the garrison/old ranges site was sold off and in 1997 the decision was made to close the site altogether with effect from 1 April 1998. Many of the buildings were converted into housing and make for an attractive and historic residential estate. (The New Ranges continues to be inaccessible and run by the military.)

The legacy of Shoebury Garrison has not been forgotten. Hill (writing in 1999) considered that 'Shoeburyness has been central to the development of ordnance over the past 150 years' and was 'the crucible of arms and armour in our modern age'.

37. Southend Central Station, Southend

By the early 1850s Southend had grown sufficiently to warrant its own railway station. This was duly delivered in 1856 with what is now Southend Central station, connecting the town to London via Leigh and Tilbury. Southend Central was the terminus of the line until growth in Shoeburyness

triggered by the garrison led to the line being extended there. Shoeburyness station opened in 1884. Prittlewell, still a separate settlement, did not get its own station until 1889, when the Southend Victoria line opened.

The original 1856 station at Southend Central was demolished and replaced in 1889 by the current one, no doubt in part as a response to the arrival of the rival Victoria line in the town. It was extended at the western end in 1899 to cope with increasing goods and tourism.

The railway brought immediate benefits. In Leigh, local fishermen used it to ship their catches more quickly to London. In Southend, it brought more visitors – and more intending residents – to the town.

The line's contractors – Peto, Brassey & Betts – purchased a large area of land on the clifftop to the west of Royal Terrace, deliberately creating a lucrative circular business model bringing people into the town, selling them houses and seeing the resulting growth attract yet more people. Their building project – Cliff Town (begun *c.* 1860) – was Southend's first planned housing estate. Its 'Nelson Terrace', now Nelson Street, provided direct access to the estate from the railway and became Southend's first shopping street. Opposite the station is Standard House, original home of the *Southend Standard* newspaper (first published in 1873).

The population of Prittlewell parish boomed as a result of these developments, rising from an average of 1,957 in the pre-railway period of 1801–51 to 12,380 in 1891.

The arrival of the railway shortened the travel time to London to one and a half hours and created a new commuter market which is still important. It also transformed Southend from a fashionable resort for the wealthy into a

Southend Central Station.

'Londoners' playground', with residents in the capital attracted by cheap tickets and easy access.

Southend was still governed administratively at this time from Prittlewell, but the inequitable growth in population created by the railway at the former soon rendered this arrangement unworkable. In 1866 Southend was given its own administrative body, the Local Board of Health, forerunner of the modern council, which ran the area covered by the ecclesiastical parish of St John the Baptist. In 1877 the growing dominance of Southend over Prittlewell was confirmed when the Local Board took over the administration of the whole of the old Prittlewell parish. Prittlewell lost its seniority and Southend was no longer governed from somewhere else.

38. The Blue Boar, Prittlewell

Since before the Southend Local Board took over the management of Prittlewell, there had been talk of constructing a more direct road between the two settlements, as travellers still had to make the journey via an awkward route, either Sutton Road or North Road. By 1841 what is now Southend High Street had been built to link the seafront at the Royal Hotel to the regionally important London Road, and a start had been made by the early 1870s on what was to become Victoria Avenue, though it took until 1889 for the latter to be completed.

Prittlewell at this time was still focussed around three roads: East, West and North streets, the last of these being the stretch of what is now Victoria Avenue

The Blue Boar, Prittlewell.

between St Mary the Virgin and the bottom of the hill. The plan for Victoria Avenue was to extend it northwards across what was then fields from the London Road and join it up with the centre of Prittlewell to form a crossroads. Unfortunately, because the south sides of both East and West Streets had buildings on them, some of these had to be demolished. One such building was a pub called the Blue Boar.

The Blue Boar had been in existence since at least 1676. It was one of a number of watering holes in the village. However, it stood in the way of progress, and despite its great age it was consequently demolished and replaced with a building of the same name, set slightly to the west. This new 1889 building was the current Blue Boar, now a well-known landmark, giving its name to the crossroads created by the arrival of Victoria Avenue in Prittlewell.

In 1906 Southend United Football Club was founded in the pub. In 1932 the Blue Boar junction became one of the first in the town to have traffic lights installed.

39. The Pier, Southend

1889 was a big year for rebuilds. Next on the agenda was one of the borough's most iconic landmarks: Southend Pier.

Before the advent of the railway, the only ways to get to Southend from London were by road and river. The latter was preferable, due to the tortuous nature of the horse-drawn coach journey over unmade roads. There was, however, a problem: the town was inaccessible by water at low tide due to extensive mudflats. The original method of disembarking from the steamboats which began to visit Southend from 1819 onwards was not a dignified one, as it involved being carried from ship to shore on the backs of local fishermen. Clearly, something needed to be done.

In the 1820s a campaign arose for the construction of a pier which would make the town accessible to river traffic at all states of the tide. One of the leading proponents was Sir William Heygate, a former Lord Mayor of London and a member of a local Prittlewell family who did much to promote the development of Southend. The foundation stone of that first, wooden pier was laid in 1829 and the pier opened for business in 1830. It proved instantly popular and by 1846 had reached 1.25 miles in length. A horse-drawn tramway was later provided on it for the carrying of passengers' luggage.

In 1875 the Southend Local Board took over the running of the pier and began to consider options to update it. More and more people were visiting it, especially now they could come to the town by train. The Local Board took the radical decision to demolish the original wooden pier and replace it with an iron one. This new pier opened in 1889 and is the one in existence today. The following year an electric tramway was opened, the first of its kind on a pleasure pier.

Southend Pier from Pier Hill.
The pierhead railway station, looking back towards the town (inset).

In 1898 the pier was extended to its current length of 1.34 miles to accommodate larger ships. In 1929 an eastern arm was added to the pier head to accommodate more ships simultaneously. The railway track was doubled and pier head attractions now included Louis Tussaud's waxworks and pleasure trips to the Continent.

During the Second World War the pier was requisitioned by the government and renamed 'HMS Leigh'. It played a key role throughout the war, as a base to monitor shipping, defend the estuary and organise convoys.

After the war, new pier trains were introduced and the structure resumed its role as a tourist attraction. It was a magnet for visitors throughout the 1950s and 1960s. However, a massive blaze at the pier head in 1976 brought all that to a premature end. There was even talk of demolishing it.

Thankfully, the pier survived and in 1986 more new pier trains were introduced. Three years later a pier museum was established to mark the iron pier's centenary.

In 2003 a new entrance was built and a replacement access bridge was put in over Western Esplanade. In 2003–04 Pier Hill was remodelled and a new attraction – a viewing tower – was erected. In 2007 Southend won 'Pier of the Year'.

In 2012 a new pre-fabricated Cultural Centre, since renamed 'The Royal Pavilion', was lifted onto the pier head from a barge. In 2015 the pier was included alongside Blackpool Tower and the Royal Pavilion in Brighton on a list of 'Seven wonders of the English Seaside' produced by Historic England.

Southend pier today is known across the globe as 'the longest pleasure pier in the world'.

40. The White Horse, Southchurch

In 1892 the local board was replaced by a town council, which was given additional powers. The following year the council renamed the town 'Southend-on-Sea'.

By this stage Southend had grown significantly and the fields of Prittlewell parish were rapidly disappearing under streets and houses. The suburb of Westcliff had appeared and it would not be long before Chalkwell too came into existence. With space becoming short, those running the town began to look outside the parish for additional land. They soon set their sights on Southchurch.

Southchurch was an unsurprising choice, as development had already begun to encroach into it along the seafront. It was duly annexed in 1897. Given how big Southend is now, 1897 seems incredibly late for the commencement of the town's expansion beyond the boundaries of Prittlewell, but that illustrates how rapid its development has been.

Southchurch was still predominantly rural and agricultural. The only developments were a cluster of buildings around Holy Trinity Church, the outlying hamlet around Southchurch Lawn and odd farms such as Southchurch and Thorpe Halls. As Southend historian William Pollitt put it (c. 1949), 'evidence is lacking before the late nineteenth century of any considerable group of dwellings which might be said to have constituted a village in the commonly accepted sense of the word'.

The White Horse in its current guise as the Old Walnut Tree.

The impact of annexation was immediate. Not only was Holy Trinity massively enlarged, but another local institution was also transformed: the village pub, the White Horse.

The White Horse had been in existence since at least 1682. In 1701 the landlord, John Darsley, had also been parish constable. Post-annexation, however, the building was too small to accommodate the anticipated development and population growth. In 1898–99 it was consequently demolished and replaced by a massive new building to the west. This new building was set slightly further back from the road to allow the latter to be widened. The plans for it show that it was originally intended to have the date '1899' inscribed at first-floor level on the western façade.

The rebuild was carried out by Luker's Brewery, which had already extended the Hope Hotel and probably the Minerva. In 1901 when the first tramways were laid in the borough, the area around the White Horse and Holy Trinity Church was chosen as one of the locations for a terminus. The White Horse has recently been renamed 'The Old Walnut Tree', hopefully temporarily.

41. The Kursaal, Southend

Southend had been a resort town since its formation out of the original fishing village in the late eighteenth century. It had been transformed during the nineteenth from a fashionable watering place into a playground for Londoners. The pier had become the major focal point for entertainment and leisure. By the dawn of the twentieth century it was time for another one.

In 1894 Alfred and Bernard Wilshire Tolhurst gave some land to the north and east of the Minerva Hotel for the creation of a public park. This 'Marine Park' was planned to provide walks, gardens, a bandstand, a boating lake, cricket and football pitches, a cycling and running track, tennis courts and a bowling green, plus shows featuring dancers, performing dogs and illusions. There were also to be sideshows and rides. From these humble origins arose one of the buildings with which Southend was to become synonymous – The Kursaal.

As the Marine Park took off, the idea arose to give it an imposing entrance. The original plan was for a tower like the one at Blackpool and the renowned architect, George Sherrin, was commissioned to design one. In 1899 the company running the park was renamed Margate & Southend Kursaals Ltd, 'Kursaal' being a universal term for a seaside entertainment venue. The name stuck.

The Blackpool-style tower never came to fruition, but what Sherrin came up with – a classical dome – became iconic. It crowned a grand entrance hall leading via an arcade to an octagon building with sideshows which opened out into the wider park where rollercoaster rides and the like could be found. This new domed 'Kursaal' opened in 1901 and over the following decades it grew into the largest amusement park in southern England. Early attractions included the ballroom, with sprung dancefloor, a visit from Buffalo Bill and a trotting track.

In 1910 two wooden rollercoasters, a bowling alley, a miniature railway, distorting mirrors and vaudeville shows were introduced. The *Southend &*

The Kursaal, showing its famous dome.

Westcliff Graphic, a local newspaper, wrote that 'the multiplicity of attractions is hardly paralleled in the Metropolis itself'. Two years later the park was bought by Clifton Jay Morehouse, who, with his son David de Forest and grandson, also Clifton Jay, established a management dynasty which would last for decades.

One of the most popular interwar attractions was the 'Wall of Death', introduced in 1929. This was made legendary by George 'Tornado' Smith, whose death-defying motorcycling rides on a vertical wall, including some with a lioness in a sidecar, drew in the crowds.

During the Second World War the park was closed and temporarily transformed into the Swallow Raincoat Factory, which made garments for troops. The famous dome was camouflaged to reduce its use as a landmark.

Post-war attractions included the legendary carnival float, The Kursaal Flyer, introduced in 1951. The 1960s saw a swift decline, however, as cheap flights to Spain tempted holidaymakers abroad. In 1973 the park and gardens closed and 20 acres of land were sold for housing. Part of the site remained in use, however, and the ballroom played host to some major rock and pop artists.

In 1986 the buildings closed, but in 1994 what remained was bought by the Council and leased in 1997 to the Rowallan Group, who restored what they could and reopened the iconic domed entrance in March 1998. The rest of the (much-reduced) site reopened in May.

The Kursaal is still open: the mainstay now is a bowling alley, with associated bars, pool tables and arcade games. Ken Crowe, who wrote an extensive history of the venue for his book *Kursaal Memories* (2003), has said of it that 'the Kursaal was, and remains, a vitally important part in the history of Southend and also in the history of the leisure industry of this country'.

42. Southend Central Museum, Southend

In the second half of the nineteenth century there was a drive to improve education in Southend. A number of schools were opened, followed by even more in the first quarter of the twentieth century. 'Education' covered more than schooling though, and there was soon talk of establishing a public library and museum.

There had been libraries in Southend before, but these had been select and patronised by the wealthy. What was needed was a truly public library, free of charge and open to all. This duly came to fruition in 1906 with the opening of the building which now houses Southend Central Museum.

The creation of the library in Southend was triggered by the Education Act of 1902 and a donation of £8,000 the following year by millionaire philanthropist, Andrew Carnegie. By 1904 the council had set up a Public Libraries Committee and commissioned H. T. Hare to design the building. The library clearly fulfilled a need: it opened in July 1906 and by November had 5,000 members.

The first museum in the town, the Southend Institute, had been set up in Clarence Road in 1884. The family of the recently deceased naturalist, Christopher Parsons, presented the organisation with a large number of artefacts, including stuffed birds, birds' eggs and notes for a book on birds of the seashore. Philip Benton presented some items of pottery found in the district. When Benton died in 1898 his widow presented more items to the museum.

Southend Central Museum, formerly Southend Public Library.
The 1974 library, with the museum behind (inset).

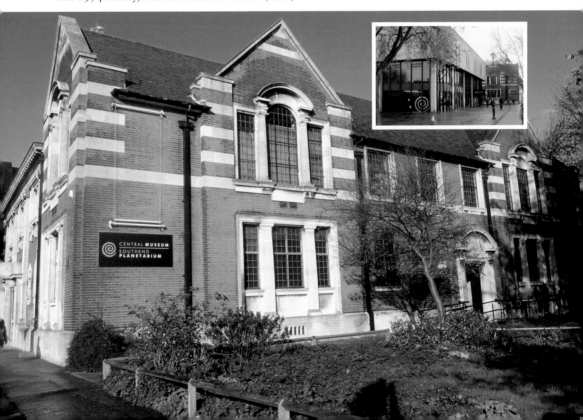

The museum's collection quickly outgrew the space available and a replacement building was sought. When the public library opened in 1906 this proved ideal and the museum collection was transferred to the upstairs landing there. The collection continued to grow and soon expanded to take up some of the upstairs rooms.

When Prittlewell Priory opened in 1922 the museum collection was transferred to the Priory. The collection grew ever larger, but fortunately Southchurch Hall was also given to the town in the 1920s and it too soon became employed for museum (and library) service.

By the early 1970s the library in Victoria Avenue had outgrown its original premises and a new, larger library was constructed next door, opening in 1974. The 1906 building was converted into Southend Central Museum, which opened in 1981. The latter also includes a planetarium. The 1974 library was converted into the Beecroft Art Gallery in 2014 after the building housing the gallery was closed and a new, larger library was opened at The Forum (see below).

The 1906 building – initially a library, then a library/museum and now the main museum for the town – has played a significant part in providing free education to the people of Southend.

43. The Palace Theatre, Westcliff

As the fields of the old Prittlewell parish began to be transformed into the Southend suburbs of Westcliff and Chalkwell, so new facilities were provided for residents in those areas. In 1912 the Palace Theatre opened on the London Road in what was now Westcliff. Over 100 years later it is still providing theatrical entertainment.

The Palace was built by Ward & Ward for the Raymond Picture Co. It originally had domes atop each of its front corners. When it opened, the theatre had a capacity of 1,500, but this has been reduced to just over 600 by later remodelling. It does, however, retain its two original galleries and four private boxes.

In late 1919 or early 1920 a widowed actress, Gertrude Mouillot, bought the Palace, possibly as a business venture or as a mark of social standing. During the British cinema boom of the 1920s and 1930s, films were shown at the Palace, but this was short-lived; live theatre has been its mainstay. Sybil Thorndike and Ivor Novello both appeared at the venue during this period.

In 1942 Mrs Mouillot donated the Palace to the local authority, on condition that local amateur dramatics groups, who were benefiting from the presence of the venue, could continue to use it. The first play presented under council ownership included a, then, unknown actress called Dora Bryan.

The main auditorium has been supplemented since the 1980s by a smaller annexe to the west known as the Dixon Studio. This development also included the construction of the current foyer, courtyard, workshops and wardrobe.

Since 2006 the Palace has been run by HQ Theatres on behalf of Southend Council. The programme includes dramas, farces and plays for children.

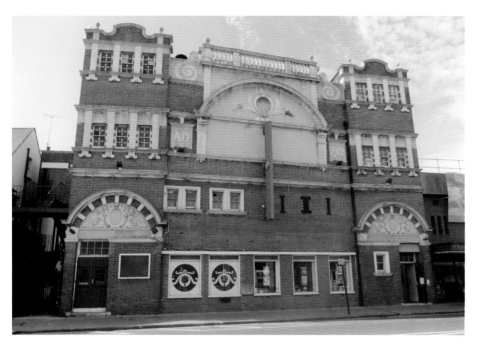

The Palace Theatre, Westcliff.

As Southend continued to spread westwards, councillors set their sights on another parish acquisition: Leigh. Since 1897 the administration of that parish had been carried out by Leigh Urban District Council (LUDC). Like Southend's, this was a forward-looking authority and by the early twentieth century it had provided many services for its residents, acquired a southern strip of Eastwood parish and renamed the town 'Leigh-on-Sea'. The arrival of the railway in the 1850s had stimulated spectacular growth. Development had been taking place inland from the church since the 1890s. The Broadway soon replaced the old fishing village High Street as the main shopping street in the town.

Around the time that the Palace Theatre was being built, Southend Council was seeking to acquire the area managed by LUDC. Approval was duly received and Leigh was acquired on 9 November 1913. On 1 April 1914 this enlarged administrative area was given additional powers and promoted to County Borough status. Southend was rapidly becoming a large modern town.

44. Southend General Hospital, Prittlewell

The growth of Southend (now comprising the old Prittlewell, Southchurch and Leigh parishes, and part of Eastwood) meant that its residents needed better facilities. One area where this was becoming essential was healthcare.

The earliest treatment establishments in the original parishes had been pest houses and isolation hospitals, essentially remote buildings in which to isolate the sick so

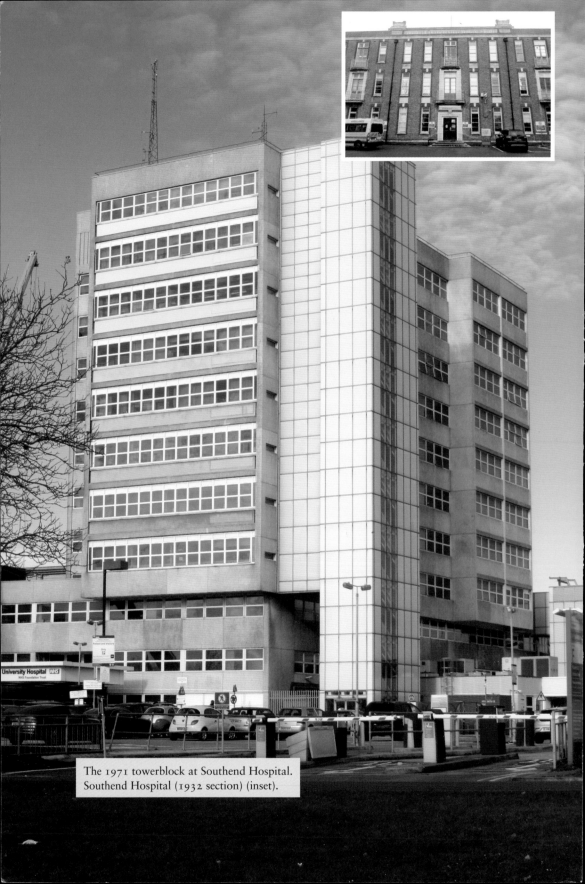

The 1971 towerblock at Southend Hospital.
Southend Hospital (1932 section) (inset).

that they did not pass on their illnesses to the rest of the population. When the Local Board was created, its members were keen to replace this somewhat barbaric practice with more modern healthcare provision. The opportunity arose in 1887 when the decision was taken to mark Queen Victoria's Golden Jubilee by erecting a hospital in Warrior Square (where the recently demolished swimming pool would later be). This 'Southend Victoria Hospital' opened in 1888. It was supplemented over the next twenty-five years by a smaller hospital in Balmoral Road (demolished in the 1990s) and by a hospital in neighbouring Rochford District. By the 1920s, with Southend's population now over 100,000, these facilities were inadequate.

In 1926 Viscount Elveden, a former Southend MP and later the Earl of Iveagh, offered 12 acres of land in Prittlewell Chase and a sum of money for the construction of a new hospital there. Alderman Albert Martin and local philanthropist Edward Cecil Jones (whose father Robert had given Prittlewell Priory to the town) also offered financial support. Southend Carnival was also established in 1926, with the express purpose of raising money towards the hospital.

In 1929 the foundation stone was laid by the Duchess of York (mother of Elizabeth II), with the council's deputy mayor, Alderman R. H. Thurlow-Baker and the Bishop of Chelmsford in attendance. The new 'Southend General Hospital' was duly constructed. It was opened by the Earl of Iveagh on 26 July 1932. The first patients were transferred from the Victoria Hospital in November.

In 1946 the National Health Service Act, effective from 1948, took hospitals out of local authority control. As Southend's population continued to grow, the hospital was enlarged in 1971 with the addition of a tower block at the eastern end, opened by Princess Anne.

In 1991 Southend became a self-governing NHS Trust and in 1995, following the centralisation of hospital services, the building was enlarged again, with the addition of the Cardigan Wing. Numerous improvements have been made on the site since then, with the hospital becoming licensed as an NHS Foundation Trust in 2006. The Carlingford Centre was built in 2010. The hospital is now known as Southend University Hospital.

The 1932 hospital was provided just in time: in 1933 Southend Council's administrative remit was expanded to incorporate into the borough the whole of the old South Shoebury parish (then run by Shoeburyness Urban District Council), the western half of North Shoebury parish, yet more of Eastwood parish and some small strips of Shopland and Great Wakering. If it hadn't happened already, 'Southend town' (focussed around the High Street) was now essentially the town centre for the wider 'Southend Borough'.

45. Southend Airport, Eastwood

Another important facility provided in the 1930s was Southend Airport, which was constructed on land in the former Eastwood parish, the bulk of which has never been incorporated into the borough. The original terminal buildings and the approach roads are, however, in the part of Eastwood which was incorporated.

Flying had been taking place on the site since at least 1909 and the basic airfield that had been established there played a key role as a fighter defence station and reconnaissance base in the First World War. After the war, the airfield reverted to pleasure flying and farmland.

In the early 1930s a campaign arose for the airport to be purchased by the council and developed into a municipal facility. This took place in 1933 and the airport was officially opened as 'Southend Municipal Airport' on 18 September 1935 by Sir Philip Sassoon, Under Secretary of State for Air. Regular flights were soon established to Norwich, Ramsgate and Rochester.

In 1939 the airport was requisitioned by the Royal Air Force (RAF). Some of the earliest Spitfires were sent to Southend to patrol the North Sea. The airport was expanded and played a crucial role throughout the Second World War. Peter Brown, who wrote the excellent *Southend Airport Through Time*, has informed the author that the oldest surviving building on the site is the RAF Stores on the northern boundary (technically in Rochford), which was erected during the war. Various wartime defences also survive.

After the war, the airport was returned to council control. Facilities were provided for customs, immigration, charter companies and night flights. The old

The modern airport: the Holiday Inn (opened 2012), designed to reflect the airport's 1930s origins.
A pillbox at the Airport Retail Park, part of a ring of local Second World War defences (inset).

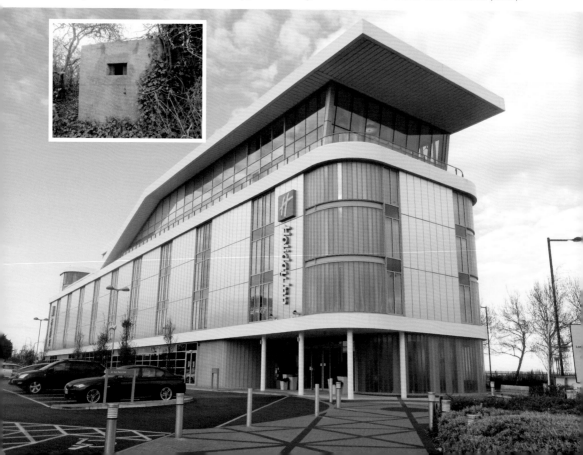

Eastwood Bury manor house which stood near the western end of the main runway was acquired for staff use, but demolished in 1954. From the late 1940s onwards companies such as Aviation Traders – established by airline entrepreneur Freddie Laker – carried out maintenance work and/or introduced regular flights to Europe.

By the 1950s the airport was a major contributor to the economy. The runways, previously grass, were surfaced with concrete and lengthened, to cater for heavier and larger planes. By the mid-1960s Southend was one of the busiest airports in the country, employing 2,000 people and handling around 700,000 passengers per annum.

In the early 1970s the airport went into decline, prompted in part by low ferry prices. The amount of freight plummeted and an increasing number of complaints from local residents about night flights also took their toll.

In May 1986, however, the council introduced Southend Air Show, an event which ran annually until 2013. At its peak it was the largest free air show in Europe, attracting 500,000 visitors. The airport provided a base for many of the aircraft on display. This, and the introduction of quieter, resident-friendly aircraft, helped bring a change in fortunes. By 1988 Southend had the fourth busiest airport in the UK in terms of aircraft movements.

In 1994 the council sold the airport to Regional Airports Ltd (RAL), who immediately renamed it 'London Southend Airport'. The terminal was refurbished, the runway resurfaced and numerous old buildings either redecorated or demolished. Night flights were also stopped.

In 2008 RAL sold the airport to the Stobart Group, who constructed a new passenger terminal and control tower, a railway station and a hotel. In 2011 Eastwoodbury Lane was closed and the following year a new south-western runway extension (made possible by the road closure) became operational.

The airport now hosts major operators such as EasyJet and Flybe. In 2015 it was named 'Best Airport in Britain' for the third year running.

Eastwood was transformed following its acquisition by the borough and the construction of the airport. Buildings in the original village 'street' between the church and Cockethurst were gradually demolished and the focus of the parish shifted to the area around Rayleigh and Bellhouse roads.

46. Roots Hall, Prittlewell

Another major venue which attracts thousands of people from outside the town is Roots Hall, the stadium home of Southend United.

The club was founded in 1906 at the Blue Boar. Its leased pitch was laid out on the north side of West Street in the grounds of a mansion called 'Roots Hall'. This name was a corruption of 'Roward's Hall', a name which dates back to the sixteenth century. The ground's original West Street entrance is now occupied by a car showroom/forecourt.

The story is not that simple, however. The team initially played at Roots Hall until only 1914, when the lease ran out and the ground was converted into allotments for the war effort. In 1919 the club moved to the Kursaal and then, in 1934, to a

The north stand at Roots Hall.

new multi-purpose ground at Southend Stadium, off Sutton Road. The latter, which had a greyhound track encircling the pitch, was not popular with fans because it lacked atmosphere. Consequently, in 1955, the club moved again, this time back to its original home. The site had been used for quarrying and as a rubbish tip since the original tenure, so required restoration. The old pitch and rudimentary stands were long gone, so a new pitch was laid and new stands erected.

The new stadium was planned to have a capacity of 35,000. Covered stands were built along the west, north and east sides. The north and east stands, originally smaller than they are now, were extended the full width and length of the pitch respectively in 1967. The west stand was doubled in size at the same time.

The stadium was officially opened by the Football Association (FA) Secretary, Sir Stanley Rous, the FA Chairman, Arthur Drewry and the Football League President, Arthur Oakley. Southend beat Norwich 3-1 in the opening fixture.

Once the 1967 extensions were completed the ground remained largely untouched until 1989 when the Taylor Report into football ground safety recommended the provision of all-seater stadiums for all the top clubs. With Southend moving up the league tables, the back section of the south bank terracing was sold off in preparation for this and developed for housing as part of Roots Hall Drive. When the club was promoted to the old Second Division (now the Championship) in 1991 it had no option but to comply with the all-seater rules. The east stand already had seating, but seats were bolted onto the terracing in the north and west stands. The reduced south terracing was replaced in 1994 with a double-tier stand. Additional covered seating was provided in the north-west and south-west corners. These changes have reduced the crowd capacity to just over 12,000.

How long United will continue to play at Roots Hall is unclear; there has been talk for several years of a move to a new 21,000-seater stadium at Fossetts Farm.

47. The Cliffs Pavilion, Westcliff

Another big entertainment venue was provided a decade later, with the opening of the Cliffs Pavilion in Westcliff.

The idea for 'The Cliffs' – a purpose-built, 500-seat theatre and concert venue – was first proposed in the 1920s and work on its foundations was begun in the 1930s. However, a shortage of money and the advent of the Second World War brought the project to a standstill. The site stood idle and incomplete for a further twenty years until the destruction by fire of an entertainment pavilion at the landward end of the pier in 1959 reignited enthusiasm for the project. A new building was erected, in part on the pre-war foundations but also on new ground slightly to the west and closer to the cliff edge. The completed building, with an enhanced 1,100-seat capacity and facilities for stage shows, banquets, exhibitions and conferences, was opened in 1964. The hexagonal sunken garden in front of the building follows the line of abandoned pre-war foundations.

The Cliffs Pavilion, Westcliff.
The Cliffs Pavilion, showing the 1992 extension (inset).

In 1991–92 the building was closed for substantial alteration. This included the construction of a balcony in the auditorium and a new, glass-fronted foyer-bar extension. Improved access from the seafront was also provided. The Cliffs reopened in December 1992 with an increased capacity of 1,630 (2,250 for standing concerts).

Like the Palace Theatre, The Cliffs has been run since 2006 by HQ Theatres on behalf of Southend Council. The programme includes West End musicals, classical and rock concerts, comedy, pantomime and children's entertainment. The Cliffs is one of the largest entertainment venues in the south-east, outside London.

48. The Civic Centre, Southend

There had been plans since the late nineteenth century for the construction of a town hall for Southend. A scheme had been drawn up in 1937, but was abandoned due to the Second World War. By 1956, however, the existing accommodation for the various council departments was at bursting point. These departments were spread all over the town, often in buildings converted from other uses, and there was a clear need to provide purpose-built accommodation and a civic focal point. A suitable plan was drawn up for a new 'Civic Centre' in Victoria Avenue.

Technically, the term 'Civic Centre' refers to a group of buildings, but it tends to be used these days solely for the Council Offices component. Construction work started in 1960 and the full set of buildings is:

- The police station (opened in 1962; being extended at the time of writing)
- The courthouse (1966)
- The council offices, comprising a civic suite (council chamber, committee rooms, mayor's office, councillors' rooms, registry office and an Assembly Room (now a restaurant)) and an administrative block (a towerblock) for council staff (1967)
- The College of Technology (1971; being demolished at the time of writing)
- The library (1974; see Southend Central Museum above)

A fire station was also originally planned, but it was instead built in Sutton Road (1964). Victoria Avenue, single-carriageway when it opened in 1889, was converted into a dual-carriageway as part of the scheme. All these buildings and many others erected in the town at this period were designed by the award-winning borough architect's department (established in 1951), led by P. F. Burridge.

The towerblock in particular was designed as a statement building, one which 'dominates the landscape and sets the pattern for the new skyline'. It was provided with a rooftop observation deck which 'affords imposing views of the County Borough in all directions'.

The council offices were opened in 1967 by HM the Queen Mother, who entered the Assembly Room from Victoria Avenue via specially designed ceremonial bronze doors (still there) which bear the town's motto and weigh ½ cwt. each.

Right: The 1967 Council Offices at the Civic Centre.

Below: Alexander House, one of the office blocks erected following the construction of the Civic Centre (whose towerblock can be seen in the background to the right); it was built in 1972–73 as the VAT Headquarters for HM Customs & Excise.

By the time of the Civic Centre's construction, Southend's population had risen to 167,000. A booklet about the buildings, published by the council *c.* 1971, is filled with pride regarding their role in establishing the town as a key regional centre.

> Southend-on-Sea now has a focal point worthy of its size and of its growing importance in the industrial and commercial world,

wrote the booklet's author.

> The Civic Centre has proved a powerful catalyst and has encouraged the development around it of a considerable amount of modern office accommodation, much of it already occupied by important Government departments and by private enterprise.

The council chamber has provision for ninety councillors. There were sixty-four councillors and aldermen at the time and only fifty-one now, so those 1960s councillors were clearly planning ahead!

Seaside trade was beginning to decline across the country at this period, so the Civic Centre and associated office developments provided an alternative way to boost the town's economy.

49. The Victoria Circus Shopping Centre, Southend

The 1960s was a watershed in Southend's history, with many existing buildings being swept away and replaced by a host of new ones. The catalyst for growth provided by the Civic Centre, the shortage of space in the town centre and the prevailing fashion for building upwards, all combined to prompt the construction of a host of multi-storey tower blocks – some commercial, some residential, even one at the hospital – and the borough's skyline changed almost overnight.

A major scheme which followed hot-on-the-heels of the Civic Centre was what was then called 'The Hammerson Development': the redevelopment of some shopping arcades to the north-east of the Southchurch Road/Victoria Avenue junction into a new shopping centre. Originally called 'The Victoria Circus Shopping Centre', it is now simply 'The Victoria'. Like the office accommodation in Victoria Avenue, this facility was provided as an attempt to boost the local economy, this time by transforming the town into a regional shopping centre.

This new development got its original name from the company which was commissioned by the council in 1964 to carry out the work: the Hammerson Group. The scheme included a multi-level, pedestrian-only shopping centre, a multi-storey carpark, an office block (Chartwell House) and an underpass linking Victoria Avenue with Southchurch Road which was home to a small bus station linked to the shops. There was also a 'shopping bridge' over Queensway (itself part of a new planned ring road) which linked the development to Southend Victoria railway station.

The Victoria Shopping Centre from the High Street.

The 'shopping bridge' at the Victoria Shopping Centre.

The shopping centre opened in 1973, with clothing company C&A as the main tenants. The scheme was so successful that its principles were copied for Southend's other main shopping centre, The Royals, which opened in 1988.

In 2006–07 the shopping centre, which was originally open to the elements, was transformed by the addition of a roof and doors. Major roadworks to replace the roundabout at Victoria Circus with traffic lights in 2010–11 involved permanently closing the underpass at the Victoria Circus end; this presented the opportunity for the shops to be extended across the site.

50. The Cultural Quarter, Southend

By the time of the opening of the Hammerson development, Southend had transformed in barely 200 years from a fishing hamlet into a sprawling modern metropolis. The boundaries of the ancient parishes had been lost and the area around Southend High Street had become the town centre for the entire borough, with smaller nucleated shopping centres and local services dispersed around both the old parish centres and the modern residential suburbs. The town continued to grow but, with the possible exception of the Garon Park leisure centre (see Fox Hall), there were no truly landmark building arrivals of borough-wide significance until the early twenty-first century when the idea for a 'Cultural Quarter' came into being.

By this stage Southend was so large that it had become a regional centre for shopping and employment. The idea of the Cultural Quarter was to make it a regional centre for education as well. In due course this would include a new statement building for a rebranded South Essex College, a campus and student accommodation for the University of Essex and modern library and teaching facilities in a building called 'The Forum'.

The college was the first of these to be built – in 2004. It was swiftly followed by the University, which was erected on the site of the old Odeon cinema in 2005–06. The university accommodation was constructed in 2009–10. This latter building is officially called University Square, but it is widely known as the 'Lego' building because of its similarity to the popular children's bricks. Last but not least, The Forum was built in 2012–13, on the site of Farringdon carpark.

It is hard with such modern buildings to know how much of a long-term impact they will have, but each is architecturally striking and they have real group value both physically and in terms of their educational function. They represent the first consciously bold architectural group statement in the town centre since the arrival of the tower blocks in the late 1960s and early 1970s.

Southend and its architecture have come a long way since the Saxons erected that arched doorway in the north wall of the then tiny parish church in rural Prittlewell in the seventh century. The town has shaped and been shaped by many of its buildings on the way. Buildings have come and gone and a book like this can only provide a snapshot of the built environment at any moment in time. It is hoped that it provides the best possible current snapshot of *Southend in Fifty Buildings*.

The Cultural Quarter, showing from left to right: the University of Essex, South Essex College and The Forum.

The 'Lego' Building – student accommodation for the University of Essex.

Appendix

Southend's Oldest Buildings

My original idea for this book was to try to identify every pre-1800 building in the borough and list them in ascending chronological order. I chose 1800 because that was when the fishing hamlet of 'South End' was morphing into the modern town. The outcome is shown below.

I have made every effort to be as accurate as possible by researching original documentation, contacting building owners and examining architectural features. Some dates in the list differ from what is commonly reported, but that is because I have consciously tried to uncover original evidence. The list contains only those buildings which I have been able to prove pre-date 1800.

I am keen to receive evidence which helps refine the dates given or proves definitively that a building I have consciously omitted ought to be included. I would also welcome information about buildings which are hidden from public view and public record, such as barns, stables, coach houses and cart sheds. If you have relevant information, please contact me via my website: www.ian-yearsley.com.

The listing details are given in the following order: name, historic parish, date of earliest surviving part(s) of the structure. In the case of the very oldest buildings which have been repeatedly remodelled, the date given may refer to only a small part of the building.

1. St Mary the Virgin, Prittlewell – pre-Conquest north wall, incorporating probable seventh-century arch.
2. St Laurence & All Saints, Eastwood – c. 1100 nave.
3. St Andrew, South Shoebury – c. 1100–40 nave and chancel.
4. Holy Trinity, Southchurch – c. 1150 nave of original church, now part of the south aisle.
5. Prittlewell Priory, Prittlewell – c. 1180 north wall of the refectory.
6. St Mary the Virgin, North Shoebury – c. 1230 chancel and possibly nave.
7. Southchurch Hall, Southchurch – c. 1321–64 core.
8. Fox Hall, Shopland – fourteenth-century timber work.
9. Swan Hall, Prittlewell – oldest timbers c. 1407.
10. South Shoebury Hall, South Shoebury – c. 1450 central section of original house.
11. Nos 269-275 Victoria Avenue, Prittlewell – c. 1450–75 according to newspaper coverage of 1989 restoration.
12. St Clement, Leigh – c. 1450–1500 north aisle, nave and tower.

13. Porters Grange, Prittlewell – *c.* 1475–1506 windows, fireplace decoration and panelling.
14. The Bellhouse, Eastwood – sixteenth-century, according to RCHM.
15. The Crooked Billet, Leigh – possibly sixteenth-century; see text.
16. Nos 62–63 High Street, Leigh – mid-sixteenth-century according to BLB; 1600 according to Edwards.
17. North Shoebury House, North Shoebury – small rear sitting room possibly *c.* 1560s.
18. The Macebearer's Cottage at Porters Grange, Prittlewell – late-sixteenth-century.
19. Cockethurst, Eastwood – built *c.* 1603 from existing ruins or foundations.
20. Leigh Park Farm, Leigh – *c.* 1619: date of earliest surviving lease.
21. The Angel Inn, North Shoebury – oldest surviving component *c.* 1650 (see text).
22. Thorpe Hall, Southchurch – '1668' date on the building.
23. Red House, South Shoebury – '1673' date on the building.
24. Suttons, South Shoebury – '1681' date on the building.
25. Angel Terrace, North Shoebury – possible late-seventeenth-century main structure.
26. Sutherland Lodge, Prittlewell – front range depicted on a map of 1717.
27. Billet Cottage, Leigh – dated *c.* 1720 by a historic building expert (not 1620 as appears on the modern sign, though it does contain reused older timbers).
28. The White House, North Shoebury – parts of previous *c.* 1728 house incorporated into present *c.* 1787 one.
29. Southchurch Lawn, Southchurch – earliest traceable ownership *c.* 1730, but possible sixteenth-century components.
30. Prittlewell House, Prittlewell – mid-eighteenth-century, but with evidence of earlier timber-framing.
31. The Old Bank House, Leigh – eighteenth-century timber-framing, probably *c.* 1750s.
32. Cockethurst Outbuilding, Eastwood – depicted on a map of 1755.
33. Parsons' Barn, North Shoebury – *c.* 1763, but see text.
34. Lawn Cottage, Southchurch – depicted on a map of 1777, but possible sixteenth-century components.
35. New Farm, North Shoebury – completely rebuilt *c.* 1781.
36. The Hope Hotel, Prittlewell (South End) – balconied section *c.* 1791.
37. The Royal Hotel & Terrace, Prittlewell (South End) – well-documented construction, 1791–93.
38. Royal Mews, Prittlewell (South End) – 1791–93, contemporary with the above.
39. The Minerva Hotel, Prittlewell (South End) – land grant 1792, building there 1793.
40. The Britannia Hotel, Prittlewell (South End) – usually given as *c.* 1790 but 'built nearly two centuries ago' according to Pewsey in 1993, so perhaps *c.* 1793.
41. Bow Window House, Prittlewell (South End) – intended construction 1795, building there 1796.
42. Nos 37-41 West Street, Prittlewell – late-eighteenth-century timber-framing.

Acknowledgements

I would like first and foremost to thank my wife, Alison, for helping me to shortlist the buildings and for offering much welcome objective advice. I would also like to thank Jenny Stephens and colleagues at Amberley Publishing for the support they have given towards this project. Special thanks also goes to Ken Crowe and Judith Williams, both of whom contributed much useful information and were very supportive of what I was trying to achieve.

I would additionally like to thank Peter Brown, Malcolm Ginns, Keith Holderness and Ellen Leslie for sharing detailed aspects of their own research, and Abbie Greenwood/Southend Borough Council for detailed information about buildings across the town.

I am extremely grateful to the many property owners/custodians who granted me access to buildings and/or provided information about them: Keith Barham; Michael Crabb; Lt Christopher Daly RN/3rd Chalkwell Bay Sea Scout Group; David Dedman; Michael Dedman; Patrick Elmore; Terry Garrett; Rev. Tom Lilley; Keith Lovell/BT Heritage and Archives; Amanda Marshall; Claire Marshall; Roy Millbank; Martin Newman; John Phelps; Mike & Jackie Roffey; Carly Ross/Southend University Hospital; David Taylor; Philip Tolhurst/ Norman Garon Trust; and Kate & Alan White.

Staff at the Essex Record Office, Garon Park Golf Complex, Madigan's Café, Southend Library and Thorpe Hall Golf Club were also very helpful, as were the ministers and congregations of the churches and staff at the public houses. Thanks also to Louise Duffin, Tony Hill and Ralph Meloy/Church of England for sharing information and pointing me in the right direction.

My thanks go to the following for making the named illustrations available: Keith Holderness, The Macebearer's Cottage at Porters Grange; Judith Williams, both photographs of Suttons; Patrick Elmore, both photographs of The White House.

Bibliography

Below is a small selection of sources used. Material relating to specific buildings is referenced in the text.

Books

Benton, Philip, *The History of Rochford Hundred* (Rochford: 1867-88)

Bundock, John, *Old Leigh: A Pictorial History* (Chichester: 1978)

Burridge, P.F., *Your Buildings 1952–70* (Southend: *c.* 1971)

Crowe, Ken, *Southend-on-Sea Past & Present* (Stroud: 2000)

Edwards, Carol, *The Old Town: Leigh-on-Sea* (Leigh: 2013)

Goodale, Alfred P., *Southchurch: The History of a Parish* (Southend: *c.* 1950)

Jerram-Burrows, Lily, *The History of Rochford Hundred – North Shoebury* (Rochford: 1981)

Jerram-Burrows, Lily, *The History of Rochford Hundred – Shopland* (Rochford: 1979)

Jerram-Burrows, Lily, *The History of Rochford Hundred – South Shoebury* (Rochford: 1978)

Pevsner, Nikolaus, *The Buildings of England: Essex* (London: 1988 (reprint))

Pewsey, Stephen, *The Book of Southend-on-Sea* (Location not stated: Baron Birch, 1993)

Pollitt, William, *Southchurch and its Past* (Southend: 1949)

Pollitt, William, *Southend 1760–1860* (Southend: 1939)

Pollitt, William, *The Rise of Southend* (Southend: 1957)

Reaney, Dr P. H., *The Place-Names of Essex* (Cambridge: 1976 (reprint))

Royal Commission on Historic Monuments (Essex: Volume IV) (London: 1923)

Sellers, Leonard, *Eastwood, Essex: A History* (Peterborough: 2010)

Stibbards, Phyl, *Our Past has a Future: The Listed Buildings of the Shoebury Area* (Shoeburyness: 1988)

Williams, Judith, *Leigh-on-Sea: A History* (Chichester: 2001)

Williams, Judith, *Shoeburyness: A History* (Chichester: 2006)

Yearsley, Ian, *A History of Southend* (Chichester: 2001)

Websites

British Listed Buildings – http://www.britishlistedbuildings.co.uk/england/essex/#.
VeLQz29RGUk
Historic England's National Heritage List – http://www.historicengland.org.uk/
listing/the-list
Essex Record Office's SEAX document search facility – http://seax.essexcc.gov.uk/
Rippon, Stephen, *Stonebridge: An Initial Assessment of its Historic Landscape
Character* – https://humanities.exeter.ac.uk/media/universityofexeter/
collegeofhumanities/archaeology/documents/Stonebridge_Park_report_FINAL.pdf
Southend Conservation Areas – http://www.southend.gov.uk/downloads/200422/
conservation_areas
Southend's Locally Listed Buildings – http://www.southend.gov.uk/info/200163/
design_and_the_historic_environment/396/locally_listed_buildings